STROUD
AND THE FIVE VALLEYS
IN OLD PHOTOGRAPHS

STROUD
AND THE FIVE VALLEYS
IN OLD PHOTOGRAPHS

———— COLLECTED BY ————
S.J. GARDINER & L.C. PADIN

Stanley J. Gardiner

Lionel C. Padin

ALAN SUTTON
1984

Alan Sutton Publishing Limited
Brunswick Road · Gloucester

First published 1984

British Library Cataloguing in Publication Data

Padin, L.C.
Stroud and the five valleys in old photographs.
1. Stroud (Gloucestershire : District) —
History
I. Title II. Gardiner, S.J.
942.4′19082 DA670.S8

ISBN 0-86299-015-7

Typesetting and origination by
Alan Sutton Publishing Limited.
Printed in Great Britain.

CONTENTS

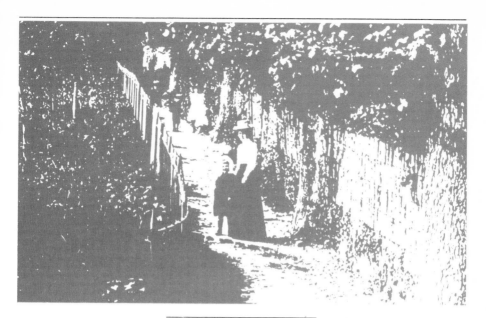

INTRODUCTION

The territory covered by this book lies, roughly, within a circle of five miles radius centred on Stroud. The period ranges over some 100 years but is mostly concentrated in the first quarter of this century. Thus a large part is still within the memory of many living today. Even so, the photographs represent a completely different way of life; much more tranquil but, in many respects, much harder. Street scenes have changed, traffic now abounds, donkeys and horses have given way to the internal combustion engine, the majesty of steam to smelly diesel, the companionship of the old village bus to the impersonalised system of today. No longer is it a major chore to keep the kitchen supplied with water, beer is brewed and 'fizzed' miles away; cinemas have come and gone, whilst industries have waxed and waned, yet life still thrives in these valleys as it has done for centuries. Stroud has become more of a geographical centre as transport has made it easier to travel outside the area, but still it serves as the administrative centre for Local Government catering for a much larger district than was envisaged 100 years ago.

The selection of photographs contained herein make no claim to be comprehensive. We have endeavoured to present a picture of the area, its industrial life, its life-style as it was – what made it tick – with, we hope, suficient historical comment to whet the appetite. There are many aspects that we have had reluctantly to exclude, for, had we included them, the sections would have been multiplied and their contents would have become sparse and disjointed. Some photographs, which we would have liked to have included, have been omitted solely because the originals were so faded that satisfactory reproduction was impossible. We have tried to give you a walk-about in the district so that places which may be unfamiliar

to you, will become more familiar if you care to walk around and ponder on the change; if so, then we shall have succeeded in our task.

Collecting these photographs has been an immense pleasure; converting them to slides, with which we have given numerous shows to many organisations over the past 12 years, has given us as much enjoyment as we know has been given to our audiences. If those shows, and this book, stimulate others to preserve what is good from the past and record the present for the future then our task will have been worthwhile.

We would pay tribute to those professional photographers of the Stroud District, – Colville, Comley, Elliot, Major, Merrett, Moss, Peckham, Smith, Stone –, to those prolific professionals of Victorian and Edwardian times – Frith and Taunt – and to all those intrepid amateurs who clicked their cameras all those years ago.

Our grateful thanks, too, to Jack Anderson, Brian Davis, Wilf Gardner, Fred Hammond, Jack Ireland, Oliver Jeffery, Dick Pegler, Geoffrey Sanders and Lionel Walrond, who have given so freely of their extensive knowledge and memories of yesteryear.

Finally, our grateful thanks to our typist, Mrs. Joan Sammons, who has so wonderfully interpreted our appalling writing.

SECTION ONE

Stroud

Stroud, as a town, is only 600 years old, before 1360 being only an outlying village in the hundred of Bisley. Only in the last 200 years or so has it really expanded downwards from Stroud Hill into the confluence of the valleys. Although surrounded by an 'Area of Outstanding Natural Beauty' it is excluded from that designation. It has always been a workaday sort of place and off the beaten track, until relatively recently, of the Cotswold tourist circuit. Were it not for Stroud's own professional photographers it is doubtful if the street scenes of Old Stroud would have been as well recorded as they have. Only the well-known areas, such as King Street Parade, attracted the attention of the national photographers. Thus, inevitably, one finds a surfeit of views of some streets and a paucity of others. The really old parts of Stroud, around and above the Cross, seem to have been poorly recorded. Even so the following should give the reader a view of Stroud as it was not so many years ago.

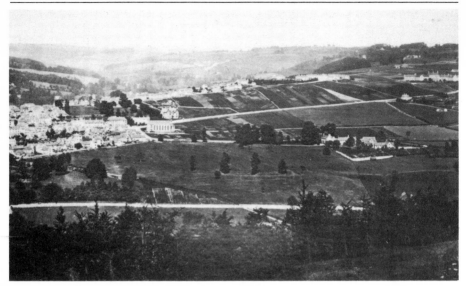

UPPER STROUD EAST from Rodborough Fort, in 1870. Left of centre is Holy Trinity Church, whilst at the extreme upper right is the Workhouse – now Stone Manor. Across the lower centre runs a very white London Road with, diagonally across it, the old private road which ran from The Castle, Lower Street, to the Arundel Mill complex. This remains today as Spring Lane

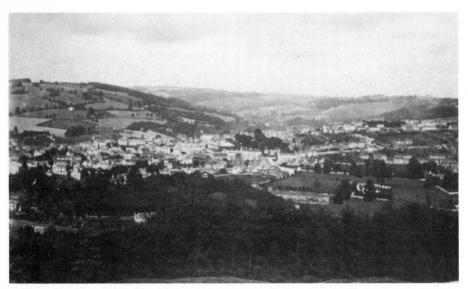

UPPER STROUD EAST. A closely similar view in 1895, showing the development of twenty-five years. Right of centre is Holy Trinity Church. In front is now the hospital (1874) and below, Upper Dorington Terrace. To the right houses are beginning to spread along Horns Road and Cemetery Road (now Bisley Road).

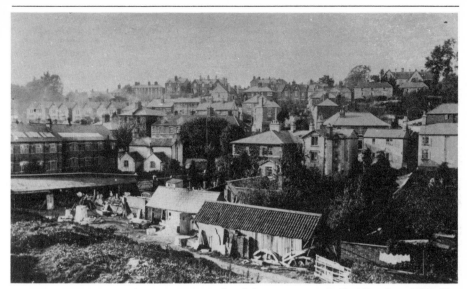

BEHIND LANSDOWN ROAD, the area to the right of the junction with Slad Road, c. 1905. The builder's yard in the foreground is the present site of Stroud Creamery. The long mill building to the left is occupied by Baughan Engineers where, in the 1920s and '30s H.P. Baughan built his cycle cars and motor cycles after removing there from Lower Street.

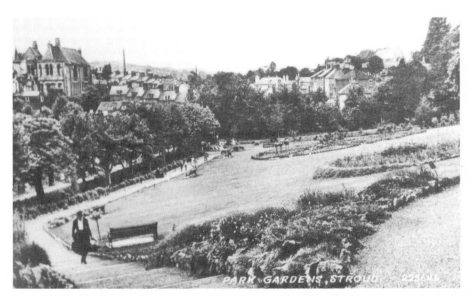

PARK GARDENS before the Cenotaph was erected in 1935. The Gardens were given to the town by Councillor Sidney B. Park in memory of his son who was killed in the First World War. The Gardens were opened on 24 March 1928 by Sir Frank Nelson, M.P. for Stroud.

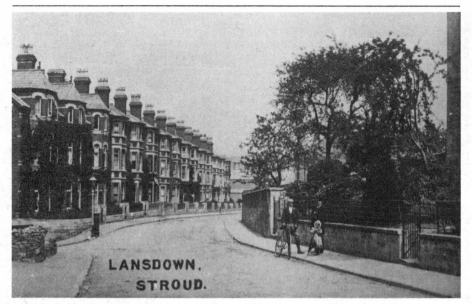

LANSDOWN at its junction with Locking Hill, pre 1890. The stone wall, lower left, surrounded the land on which the School of Science – now the College of Art and Stroud Museum – was to be built in 1892. Rather faint, beyond the terrace, is the Synagogue.

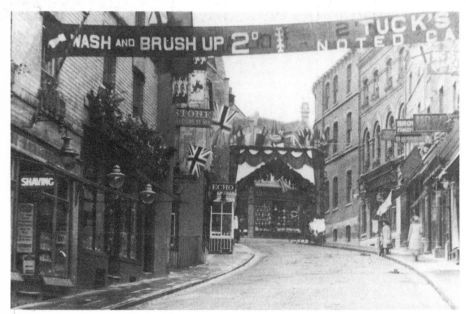

GLOUCESTER STREET. The arch at the top of the street, probably erected by Philip Ford & Son for the Agricultural and Horticultural Show, suggests a date of 1912. In the 1930s Stone's Refreshment Room was Stroud's Faggot and Pea Shop.

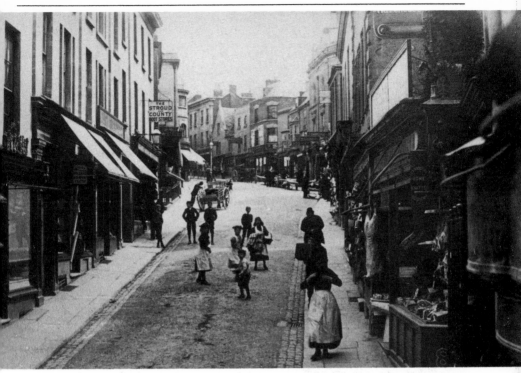

HIGH STREET, looking up from just below the junction with Bedford Street, c. 1890. By the Kendrick Street junction the barrows of the fruit and vegetable and fish traders can be seen. Note the dirt and stone road and cobbled gutters; the butcher's display open to the elements

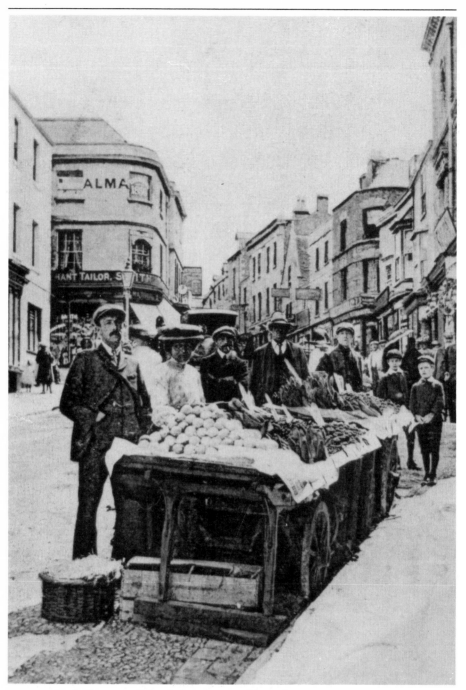

HIGH STREET. A close-up of the fruit and vegetable stalls.

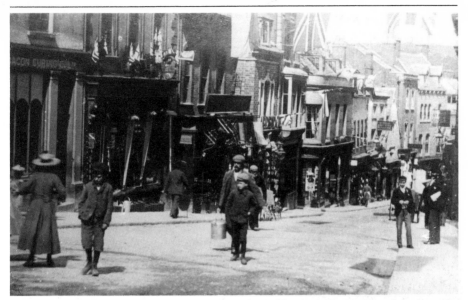

HIGH STREET, looking down from the junction with Kendrick Street. The flags may be decoration for the Agricultural Show or the 1902 Coronation. At the junction with Kendrick Street was the shop of Hilliers Bacon Curing Co. The shop on the lower side of Bedford Street junction was the Waterloo Pharmacy – now Polkinghorne's.

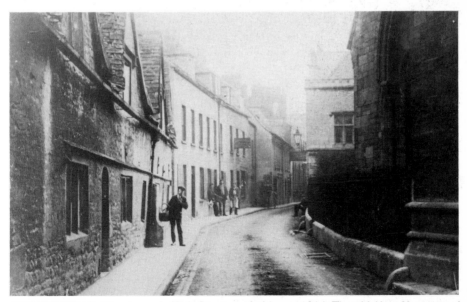

CHURCH STREET, looking towards High Street, probably pre 1914. The old Alms Houses and the terrace beyond, where the men are standing, were demolished c. 1960, the ground now being part of the Church Street car park.

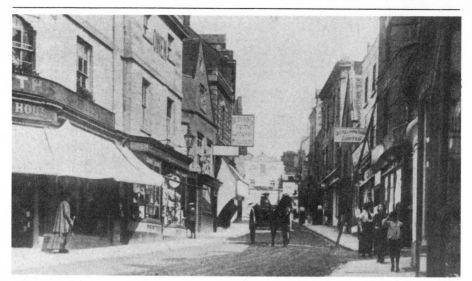

UPPER HIGH STREET, C. 1910. On the left, Smiths Alma House and next, Owen the printers, now combined into Witchers Menswear. Halfords occupied the printing shop for a time followed by Zachary Wine Merchants. The large house at the top of the street was a dressmaking establishment called Paris House. It was demolished to make way for the Stroud Co-op Showrooms and Bakery built in 1931, now used as a launderette etc.

THE HOSPITAL, C. 1905. On the right, where the Maternity Unit has now been built, stood Cowle's Observatory. He was a benefactor of Stroud, donating land for the hospital and founding the museum.

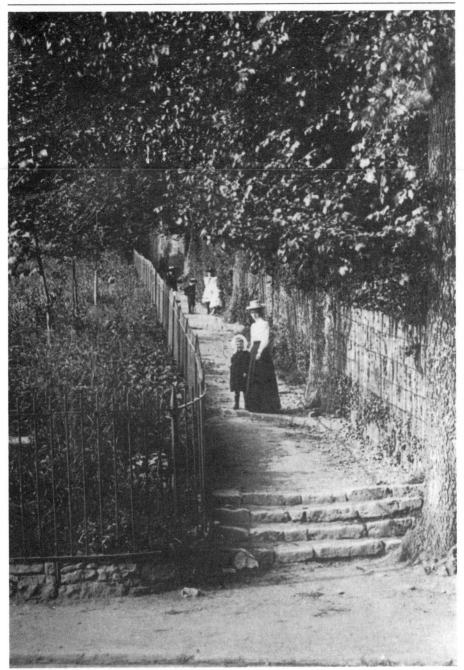

CASTLE STEPS from London Road, 1898. A picturesque and tranquil part of Stroud now sacrificed to housing development.

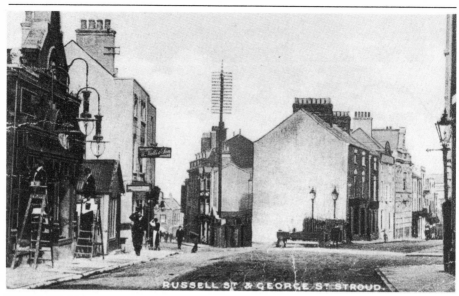

THE VIEW FROM LONDON ROAD, c. 1905. The horse trough for the horse cabs stood where Sims Clock stands today. Beyond, the iron railings surround the Gents toilet, still there below the Clock Tower. An early telephone pole stands at the rear of the old Post Office Inn.

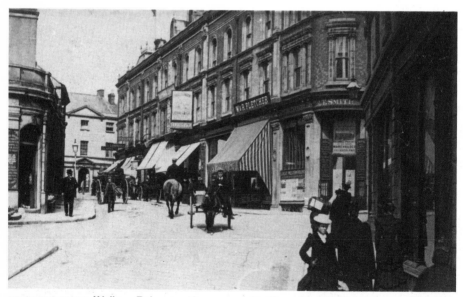

KENDRICK STREET. Walkers Bakery on the corner with Threadneedle Street was then used as offices by R.T. Smith, carriers to the G.W.R. Fawkes & Sons' sign projects half way along. They were high class grocers and became the No. 1 store of the Cotswold Stores Group. The building on the left, now the pet shop, was a finishing room for the Holloway factory in Threadneedle Street.

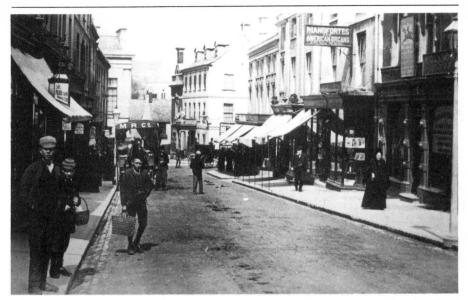

GEORGE STREET. Suggested date is the 1890s. On the left, Sheltons picture framing shop; they had a shop in King Street by 1902. On the extreme right was the Midland Railway carriers office, one of their vehicles being on the left. At the bottom of the Street, the Royal George Hotel.

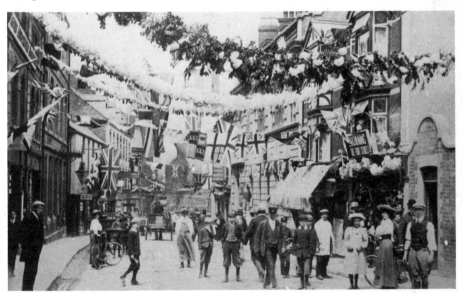

RUSSELL STREET decked out for either the 1911 Coronation or the 1912 Agricultural Show. The rear entrance to the Post Office Inn on the right. Beyond the Wilts. and Dorset Bank, the large signboard of the Forresters Inn. Note the very ornate gas lamp bracket on Stroud's second Post Office.

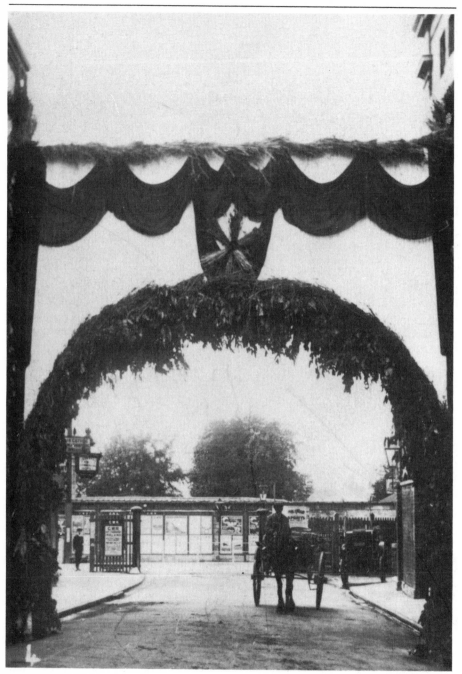

STATION ROAD. An arch erected by Philip Ford & Son for the 1912 Agricultural and Horticultural Show.

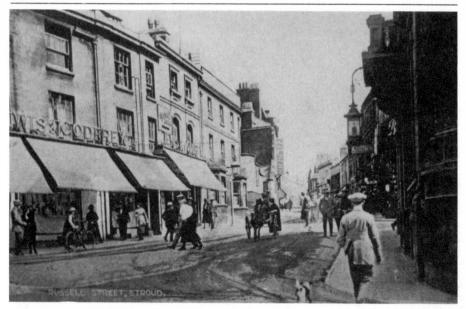

RUSSELL STREET from Rowcroft, c. 1920. Below the gas lamp on the right can be seen the sign of the Temperance Hotel in a strategic position opposite the Railway Inn and the Forresters Inn.

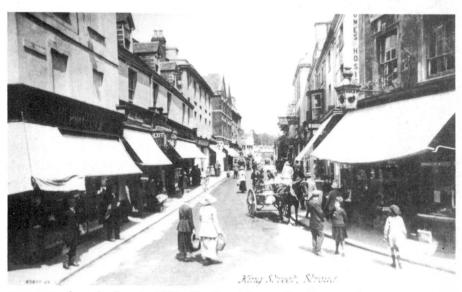

KING STREET from the Parade, 1920s. The Royal George Hotel has now been converted to a shop on the ground floor occupied by Hepworths and the upper floor to a cinema – The Picture House – the exit sign from which can be seen on the left, being where the entrance to the Lucania Billiards Saloon is today. The shop beyond the sign was Woolworths.

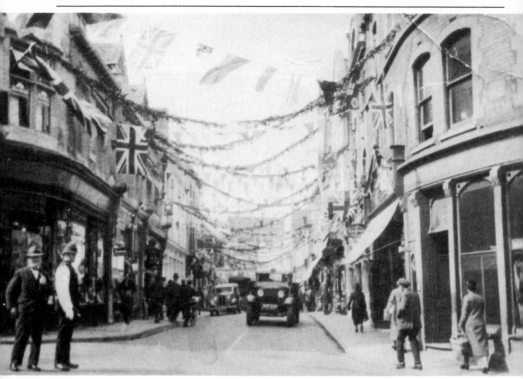

KING STREET from Lansdown, bedecked for the 1935 Jubilee. Standing by the point duty policeman is Osborne J. Leach, founder of the Insurance Broking Co. and a founder member of the Cotswold Players. Town Time can be seen on the right, encased in the wall of Rufus Weston's shop. The clock was a watchmakers regulator, used by Robert Bragg who was a 'Jeweller, Optician & Watchmaker' at No. 1 High Street in 1867. It always showed G.W.R. (or London) time. The mechanism has now been restored and placed in the Library. The lorry approaching is a Ford Platform Truck of the G.W.R., Reg. No. BGP 239.

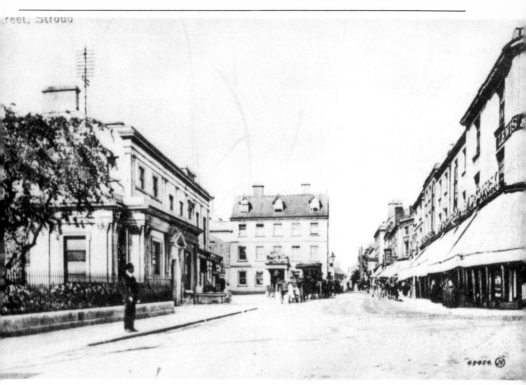

KING STREET PARADE, c 1910. The Royal George Hotel (facing) was originally a house. It was used by a Stroud–Bristol carrier c. 1800, and then became the Kings Arms Inn. In 1818 it was purchased by Thomas Wall, owner of the old George Inn in the High Street, who rebuilt it in the style shown here and renamed it The Royal George Hotel. The building to the left – now Woolworths and Hiltons – was the Victoria Rooms built in 1831 as Public Rooms. Not being a financial success because of the superior accommodation of the Subscription Rooms, it was converted into two shops and dwellings. Behind the tree is Rowcroft House, which became a Banking House in the mid 1800s, eventually passing to Lloyds Bank Ltd., who replaced it in 1930 with the present building.

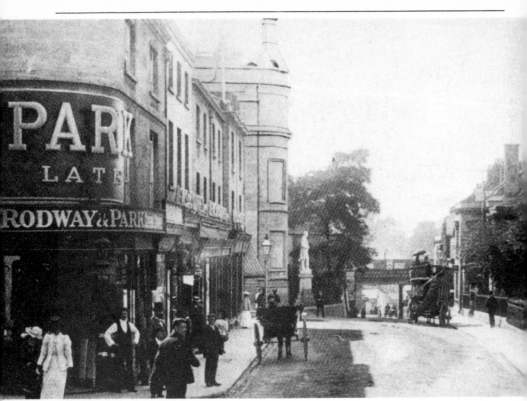

KING STREET PARADE in the period 1895–1901. A horse-bus about to negotiate Rowcroft. On the left, where the Midland Bank is today, is the shop of Sidney B. Park, milliner and draper (see p. 11). Holloway House, behind George Holloway's statue, was opened in 1895. The bridge carries the advert of Godsell & Son, Brewers, of Salmon Springs Brewery.

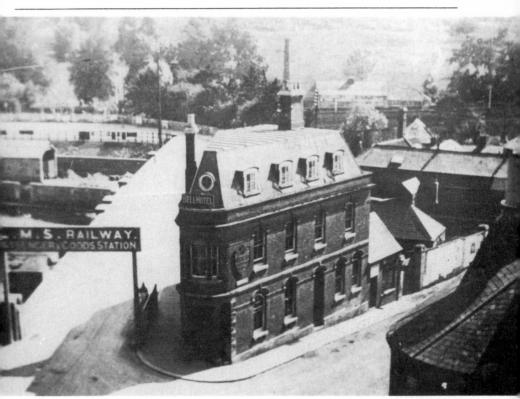

WALLBRIDGE INDUSTRIAL ESTATE. The entrance, as it was in the 1930s. In front of the shed, left centre, the Thames and Severn Canal above Wallbridge Upper Lock. The building on the right, with the round air vent, is part of the bottling department of Stroud Brewery, from whose office windows this photograph must have been taken.

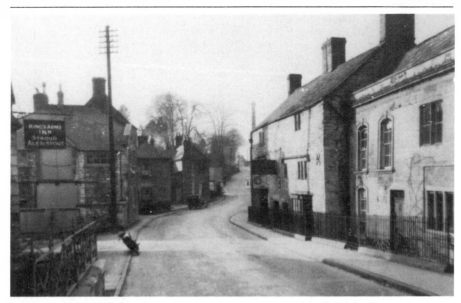

WALLBRIDGE in the 1930s. The buildings on the right stood where Butt's customers' car park is today. The Kings Arms has also been demolished in the Butts alterations.

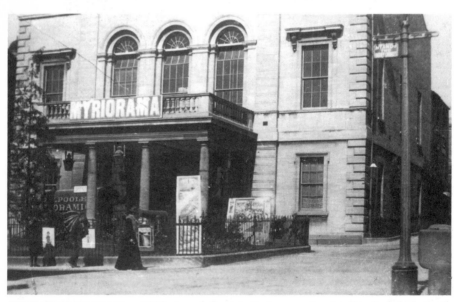

THE SUBSCRIPTION ROOMS, c. 1900. Joseph Poole's Myriorama showing 'Dr. Jim's last stand'. One might call these shows the original travelling cinema. The advertisements and reports indicate a varied bill of films, current news items, animated scenes and live variety accompanied by Poole's own orchestra. Usually the rooms were hired for a week of evening shows with matinées on Wednesdays and Saturdays; seats varying from 6d to 3s.

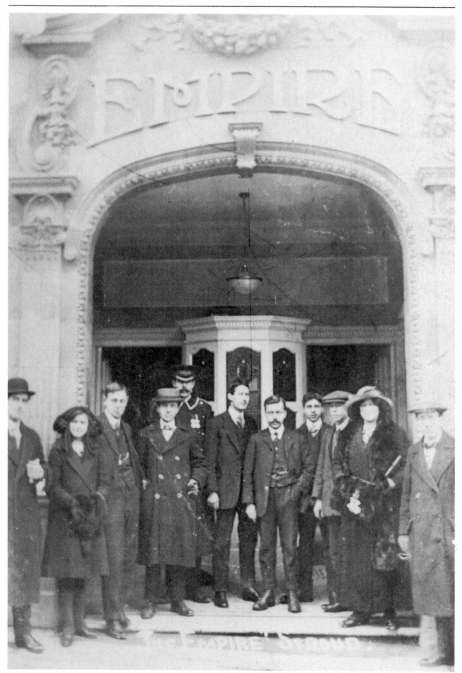

THE EMPIRE CINEMA, London Road, during opening week in 1913. Later it became The Palace Theatre, the Gaumont and on to the Mecca of today.

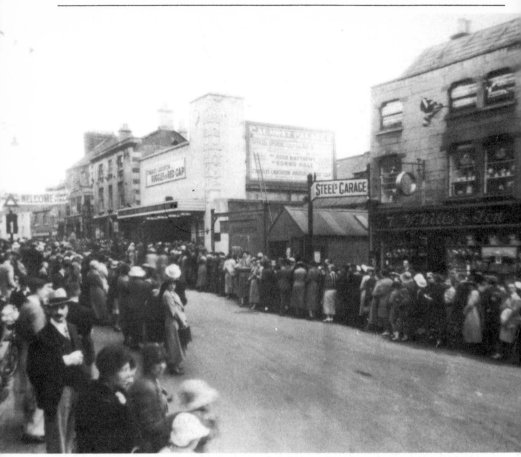

THE NEW GAUMONT PALACE. Crowds awaiting the arrival of the film stars Jessie Matthews and Sonny Hale for the opening on the 31 August 1935. The ceremony was performed by Tom Langham J.P., Chairman of Stroud U.D.C. The opening film for the first three days was Charles Laughton in 'Ruggles of Red Gap'.

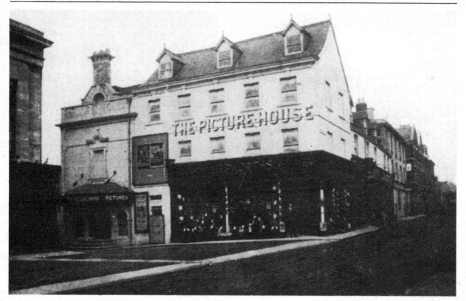

THE PICTURE HOUSE in the converted Royal George Hotel in the early 1920s. It survived as a cinema for some twenty years until redevelopment of the site by Burtons the Tailors took place, in the late thirties.

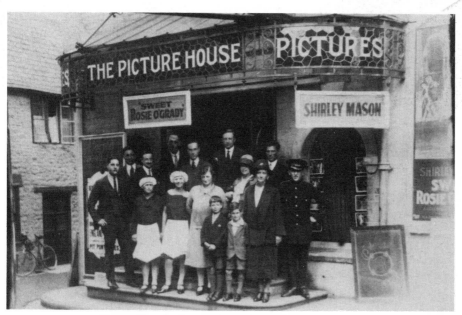

THE PICTURE HOUSE. The staff, and a few others, in the 1920s. The building on the left was the George Tap Inn, the landlord being Echo Organ. In the redevelopment of the late thirties it was demolished to make room for the new Ritz Cinema.

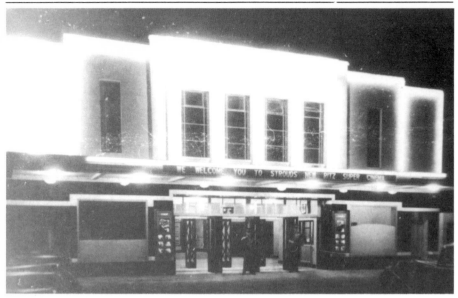

THE RITZ, soon after opening in 1939. The restaurant on the upper floor became a British Restaurant during the Second World War. It was burnt down in 1961.

The Valleys and Hills

Five main valleys radiate from Stroud. Stonehouse Valley can be considered as an inlet from the Severn Plain into the Cotswold scarp, then clockwise the others are Painswick, Slad, Chalford and Nailsworth. The hills separating them are Whiteshill, Wickeridge, Stroud and Rodborough.

Fortunately for us those enthusiastic 'camera clickers' have recorded their everyday views, little realising that their efforts would become historic gems in such a short time, as the pace of change quickened.

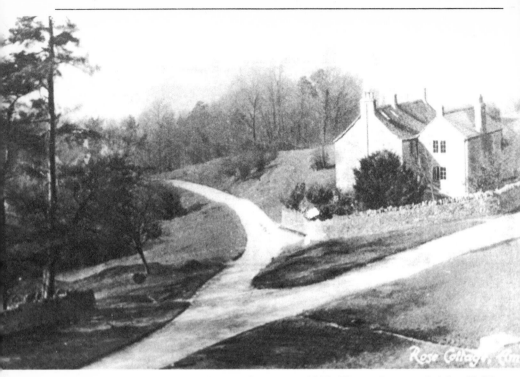

AMBERLEY. An unusual view of Rose Cottage c. 1920. The authoress of *John Halifax, Gentleman* lived here.

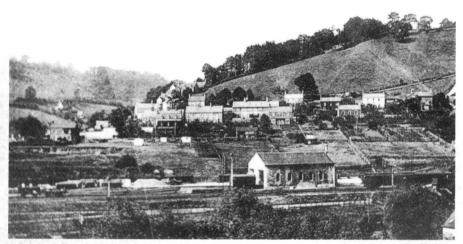

BRIMSCOMBE. A view from the Knapp across Brimscombe station goods yard to the Bourne, pre 1900. The Stroud–Chalford road then passed behind the goods shed, whereas today it passes over its site. The quarry was probably the source of clay for the brickworks which were active on this site c. 1860.

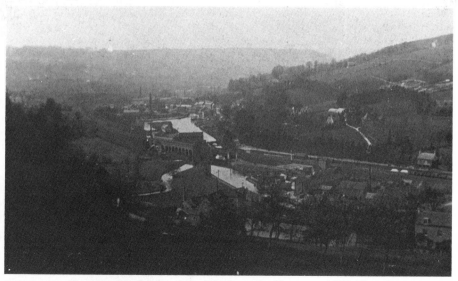

BRIMSCOMBE. View towards Brimscombe Port from the Knapp, c. 1905. This shows the vast expanse of water known as The Basin and shows the island to the left constructed to store goods for trans-shipment, to prevent stealing. At the end of the island is the warehouse which became Luggs Foundry and later passed to Hewins. The wide part of the canal in front of the railway bridge shows the entrance to the dry docks of the boat building yards.

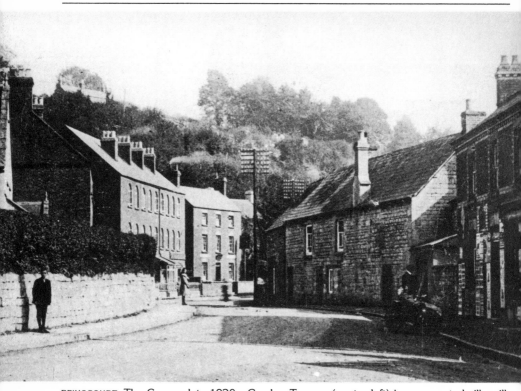

BRIMSCOMBE. The Corner, late 1920s. Gordon Terrace (centre left) is a converted silk mill. The bay window was Mr. Castledine's, the barber. On the right, the telephone sign is on the first Brimscombe Telephone Exchange. Next door was Thwaites, newsagents. All the buildings on the right were demolished to make the new junction.

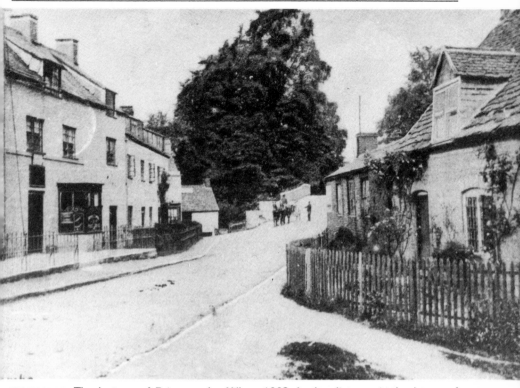

BRIMSCOMBE. The bottom of Brimscombe Hill, c. 1902. In the distance is the hump of Brimscombe canal bridge. The shop on the left was Brimscombe's Post Office. Mr. Ernest Barrett, Chief of Brimscombe Fire Brigade, lived in the cottage on the right, and the Institute building was next door.

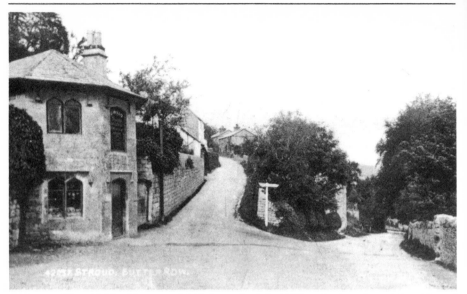

BUTTEROW. The old Pike House, c. 1912. It was built in 1825 at the junction of the old road with the new, less steep road from Bowbridge to the Bear Inn. For many years it was a small shop.

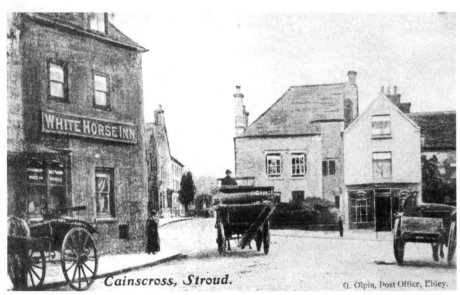

CAINSCROSS. The crossroads, c. 1905 with a horse-bus going towards Stroud. The White Horse Inn is still the same except for the loss of the small shop. The houses and shop beyond the bus were demolished about 20 years ago to make room for Tricorn House and the road alterations. The bow-fronted shop was Garraways Chemist Shop before closure.

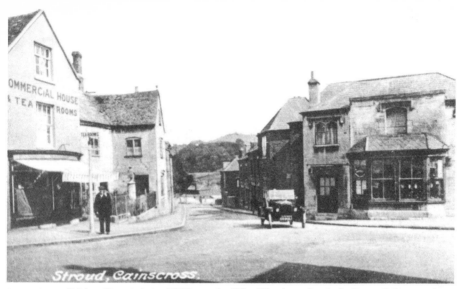

CAINSCROSS. Bridge Street, liate 1920s early '30s. The bow-fronted shop of the previous photograph is now Tea Rooms. It has also been called Sundial Cafe and the sundial stands in the garden beyond. The latter is now outside Tricorn House.

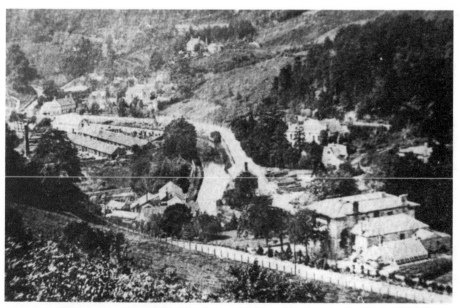

CHALFORD. The west end in 1873. The house bottom right is now the Springfield House Hotel. Immediately over it's roof is a small house which stood close to the present day bus terminus and was Chalford's first Post Office. It was demolished in 1885. The buildings to the left of the canal are part of the Bliss Mills complex.

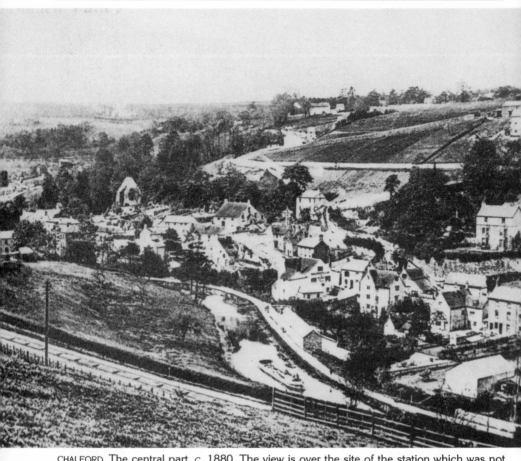

CHALFORD. The central part, c. 1880. The view is over the site of the station which was not built until 1897. The railway lines would have been converted to standard gauge by then but are still the broad gauge pattern. The house beyond the barge, with the writing on the wall, is the Red Lion Inn as it was before the fire of 1885.

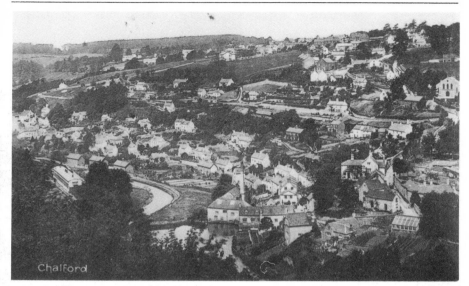

CHALFORD. The east end c. 1905. Middle foreground is Sevilles Mill, now demolished. To the left the Thames and Severn Canal sweeps round from Clowes Lock into the Narrows to pass the mill pond. The bulding in the trees to the left is the engine shed for the Chalford Railcar, burnt down on the night of 8 January 1916.

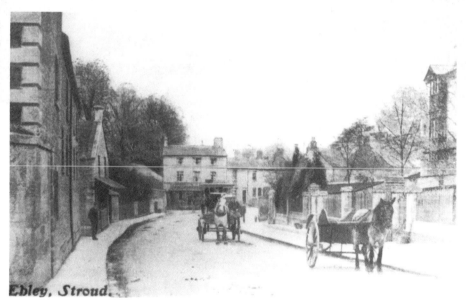

EBLEY, from the present day Motor House entrance c. 1905. Townsends shop on the corner was then Bassetts, a general stores, dispensing paraffin oils from the shed on the left (roof visible). The canopied shop, opposite what appears to be a horse-bus, was that of Smith Rogers & Co., bacon curers, whose factory was behind.

KINGS STANLEY. Village Green and War Memorial early 1920s. The ornate head of the Memorial held a lantern which automatically lit up every night and shone until 11 p.m.

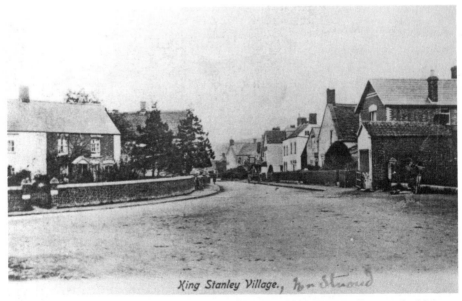

King Stanley Village.,

KINGS STANLEY. Junction of High Street and Bath Road c. 1905. The single storey building on the right is now Pearce's butchers shop.

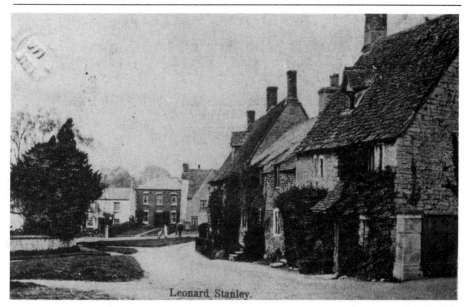

LEONARD STANLEY, 1905. Cottages near the church. The War Memorial now stands on the green where the woman with the push-chair is standing.

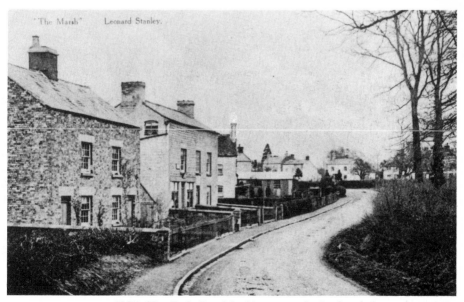

LEONARD STANLEY, c. 1905. The Bath Road looking towards the Lamb Inn.

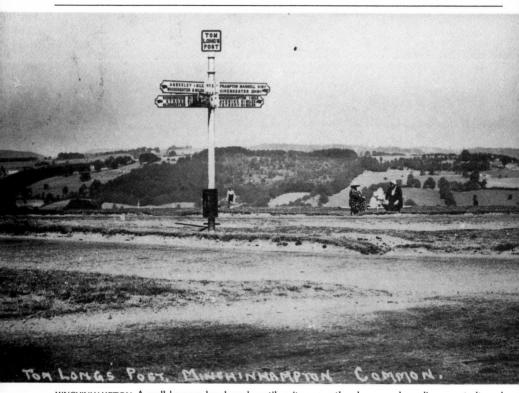

TOM LONGS POST - MINCHINHAMPTON COMMON.

MINCHINHAMPTON. A well-known landmark until quite recently when road re-alignment altered this juction. Poor Tom Long, a Box weaver, could never have realised that, driven to suicide and buried close to this spot, he would be remembered in legend as a highwayman.

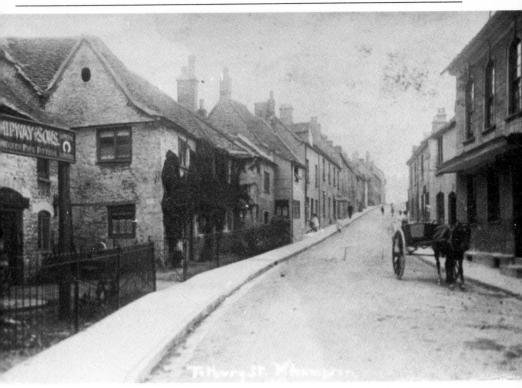

MINCHINHAMPTON, probably about 1900. Jehu Shipway & Sons was founded in 1812; where is not known. In 1895 they built a new works at Ebley, where Freeway Plant Sales is today. They were plumbing and heating engineers as well as smiths. On the ground, by the sign is the platform used for shrinking iron tyres onto cart wheels. The trap outside the Post Office will take the mail to Brimscombe.

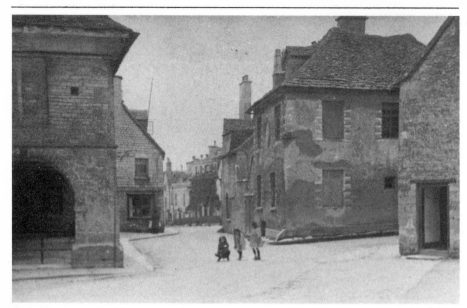

MINCHINHAMPTON. High Street from Butt Street, pre 1914. The Market House on the left. The buildings occupying the site of the war memorial were known as Lower Island. They were used, amongst other things, for the school cookery classes and were demolished in 1919.

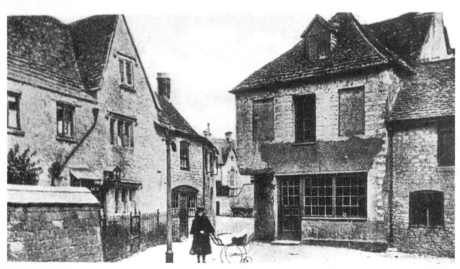

MINCHINHAMPTON. Bell Lane corner pre 1914. The other side of the Lower Island buildings. Note the bird cage on the house wall.

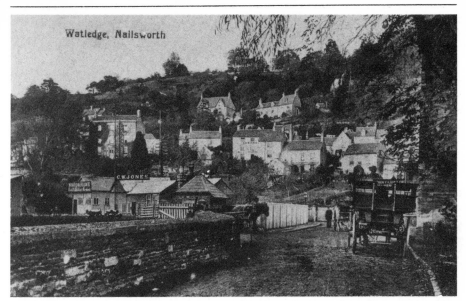

Watledge, Nailsworth

NAILSWORTH. Entrance road to the station c. 1905. The vehicle on the right appears to be a rear entrance horse-bus. Beyond, the office of John Farmiloe, coal merchant. Behind the tree, the Station Hotel, once a private house called Corunna.

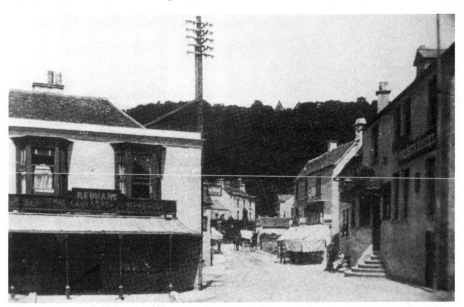

NAILSWORTH. George Street, c. 1900. The George Hotel on the right. Waterloo House, beyond, has been replaced by the Midland Bank. Redmans shop passed through several owners until demolition in 1959 to make way for the landscaped area surrounding the Clock Tower.

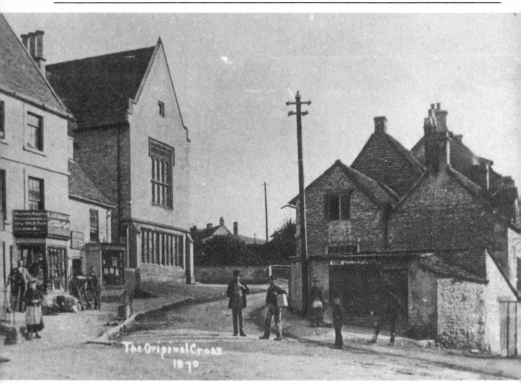

NAILSWORTH. The Cross in 1870 with a very narrow Bath Road beyond. The lady on the extreme left is standing in the doorway of the chemists, Smith & Son. The next shop is that of S.J. Newman, ironmonger, the man standing by the window being Samuel Newman, co-founder with Francis Joseph Hender of Newman Hender & Co. Ltd. The next shop was the Post Office, with the Subscription Rooms beyond, which were later to become the Nailsworth Cinema. The man standing in the middle of the road is 'Barmy' Waite. To his left is a very early telegraph pole next to a shop which sports a notice 'fish'. Behind that the Kings Head Inn.

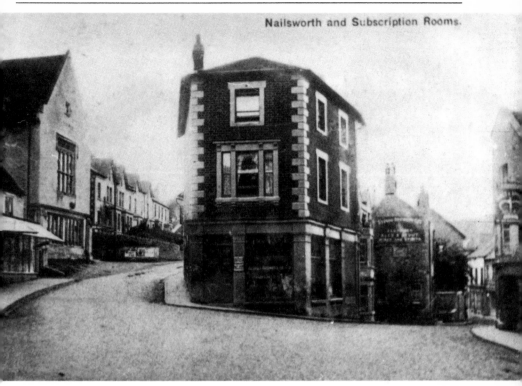

NAILSWORTH. A similar view to that on p. 46, c. 1910. The brick building was erected in the 1890s and was first used as a bank, believed to be a Wilts. & Dorset branch. Later it became a laundry shop and then offices. It was demolished in the late 1950s.

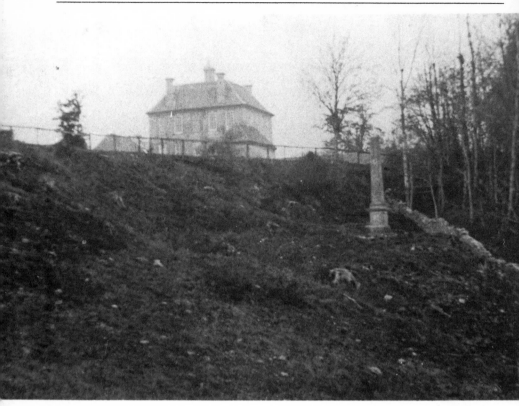

NETHER LYPIATT. The Manor House, now the home of the Prince and Princess Michael of Kent, from Mackhouse Woods. Thought to be early this century when the house was a farmhouse. The memorial to Judge Coxe's horse on the right. Formerly there was an iron plaque on the base which, according to the Bisley historian, Miss Mary Rudd, bore the inscription:

> My name was Wag, that rolled in green
> The oldest horse that ever was seen
> My years they numbered forty two
> I served my master just and true.

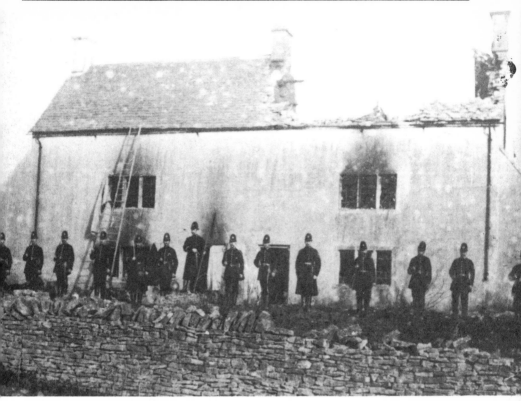

OAKRIDGE. The aftermath of the fire at the Pest House on the Waterlane road, 1895. Built about 1779 to house inmates of the Bisley workhouse suffering from smallpox. Consequent upon a smallpox outbreak at Stroud in 1895, it was resolved to use the Pest House for Stroud cases, but feeling in Bisley against the house being used for Stroud people was such that a band of men attacked the 'ambulance' and turned it back. Before police could arrive, they had returned and set fire to the Pest House. Sentences meted out to the rioters – one month to one year's hard labour.

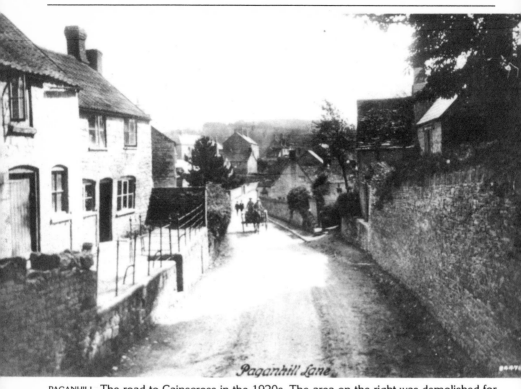

Paganhill Lane

PAGANHILL. The road to Cainscross in the 1920s. The area on the right was demolished for road widening and for the entrance to the Fire and Ambulance Stations.

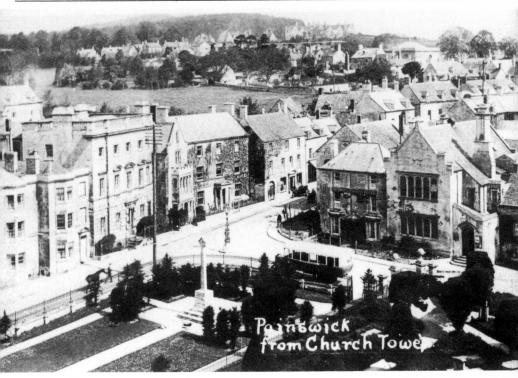

PAINSWICK. The Jubilee Lamp, which is now perched on the churchyard wall behind the War Memorial, is in it's original position in this 1920s photograph. The house beyond the bus, now Lamp House, was then the Cotswold Private Hotel.

PAINSWICK. Friday Street, pre 1900. The shop is now Hamands Antiques. The two-storey addition has now disappeared, opening up the whole wall of the adjacent house.

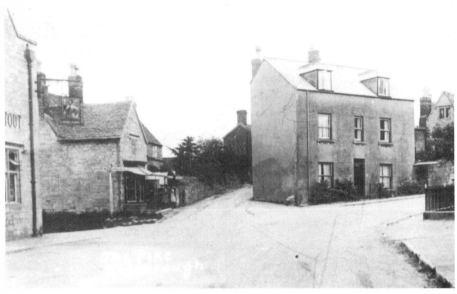

RODBOROUGH, early 1920s. The sign of the Prince Albert Hotel on the left. The house on the right, Upways, was demolished in the 1960s. The house on the left of the lane was the Post Office.

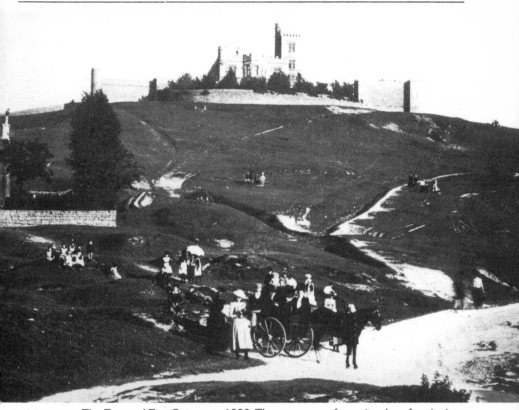

RODBOROUGH. The Fort and Fort Cottage c. 1900. Then, as now, a favourite place for picnics.

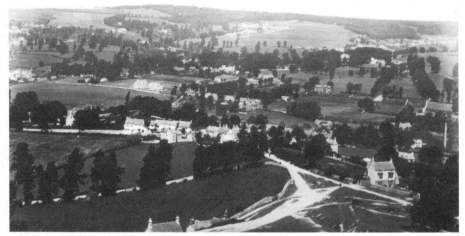

RODBOROUGH. The North West view from the Fort in 1891. Just left of centre are the two newly erected buildings of Marling School. Extreme left centre, Carpenters Brewery at Cainscross. The wide white road in the foreground is the old Stroud–Cirencester Road cut in 1745.

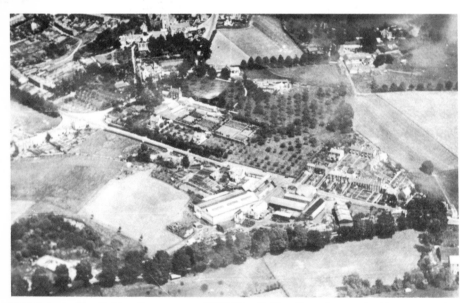

RODBOROUGH. The Golden Cross area c. 1925. The Golden Cross Inn can just be seen on the lower side of the crossroads. Opposite are the Rodborough Nurseries, with, below, T.H. & J. Daniels' factory.

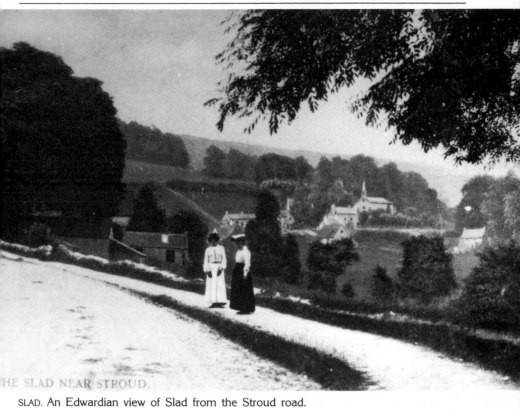

THE SLAD NEAR STROUD.

SLAD. An Edwardian view of Slad from the Stroud road.

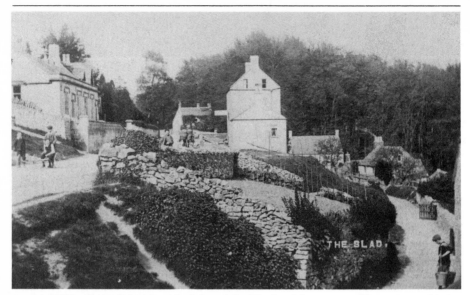

SLAD, C 1907 with the School on the left and the Woolpack Inn, centre. The cottage with the smoke issuing from the chimney has been extensively altered and is now The Little Court, the home of Laurie Lee.

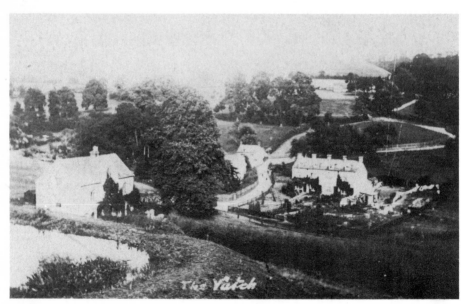

SLAD. The Vatch from the Stroud road about 1912. The embankment of the pond can still be seen behind the bus-shelter.

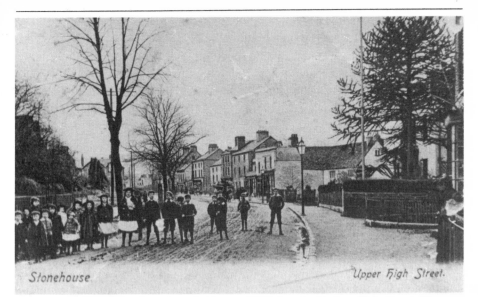

Stonehouse.
Upper High Street.

STONEHOUSE. East from the railway bridge, c. 1910, in a traffic-free High Street. The area beyond the monkey puzzle tree is now the entrance road to the Park Estate and to the War Memorial Green.

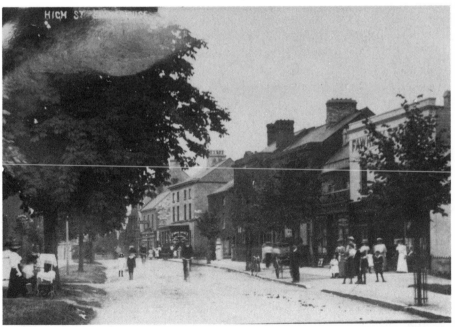

STONEHOUSE. A tranquil High Street scene early this century. Fawkes Stores on the right, now Barclays Bank.

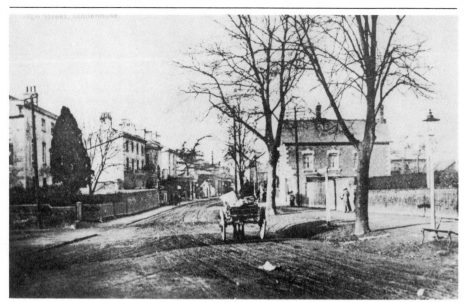

STONEHOUSE. West along the High Street from Regent Street c. 1905. The area on the right is now occupied by the Post Ofice and a row of modern shops. The house is now the Midland Bank.

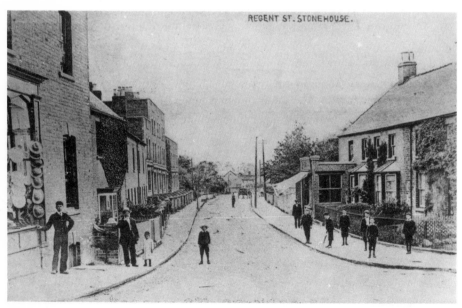

STONEHOUSE. Regent Street, c. 1905. The shop on the left would have been Barnets, drapers and tailors. The shop on the left with the awning is now the Polly Owen Boutique. The house by the boys is now the Clock and Watch Shop of S. Neno & Sons.

SECTION THREE

Transport – Road and Rail

The decision of the Cheltenham & Great Western Union in the 1840s to extend the Railway from Kemble to Gloucester was a great step forward. It meant that a direct line from Gloucester to Paddington was now available, plus, of course, local connections. The line was opened in May, 1845. During the construction of the line, between the west end of Sapperton Tunnel and Cainscross, several timber viaducts were built over valleys or rivers. These were encased with brick after 1859 and are as we see them today.

The Stonehouse and Nailsworth Railway was opened in 1867, but, as this company had no rolling stock it was operated by the Midland Railway who eventually took over control of the line.

The extension from Dudbridge Junction to Stroud for passenger traffic was opened in 1886. Regular operation for the whole line officially ceased in June, 1947, though some goods traffic plus a few enthusiasts' specials continued until the mid 1960s.

Early Motor Buses were operated in the Stroud area by Arnolds & Jefferys' from Nailsworth. Grey Motors of Minchinhampton began a Stroud service in 1921. The G.W.R. did so too from Cainscross, Painswick, Cheltenham and Chalford from about 1905. The Red Bus Co. of Landsdown, Stroud had a large number of routes in the late 1920s and early '30s. The Red Bus Co. was started by a former Australian airman, N.D. Reyne, who had served at the old Minchinhampton Aerodrome, 1916–18.

With the coming of the National Omnibus Co. to the Stroud District soon after the first world war, our local services were on a sound and competitive basis, to the advantage of the travelling public.

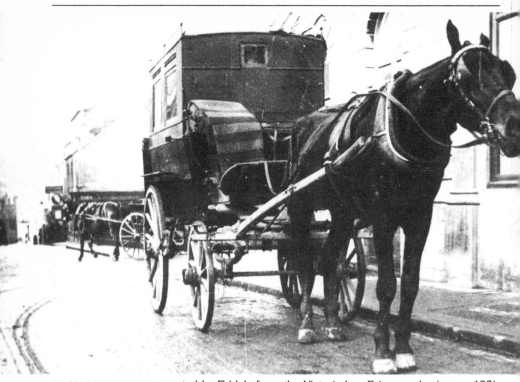

A HORSE-BUS SERVICE operated by Eddels from the Victoria Inn, Brimscombe (see p. 133). Here, the Winter bus on the Stroud–Chalford service, stands outside Kendrick Hall, Stroud, (now Bateman's Sports Shop) in 1902.

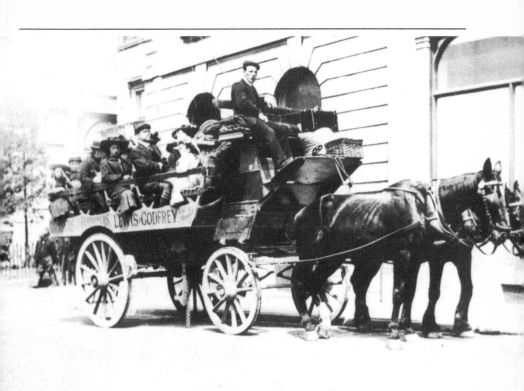

THE SUMMER BUS at the same spot, 1902.

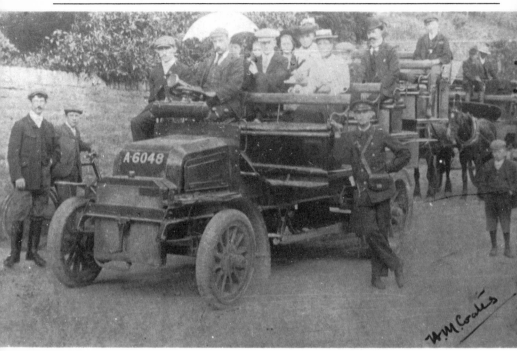

AN EARLY GWR MOTOR BUS at The Grove terminus, Chalford, in 1905. It was a Milnes-Daimler vehicle. The opposition horse-bus stands behind. The GWR only ran their buses to Chalford for about three months in 1905 to supplement the Rail Motor service. The tall gentleman standing on the left is the late Mr. W. Young who died at Bournes Green in 1983.

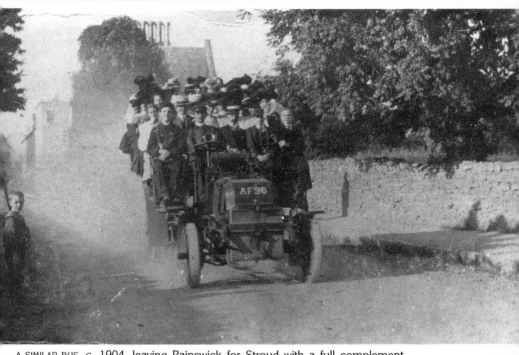

A SIMILAR BUS, C. 1904, leaving Painswick for Stroud with a full complement.

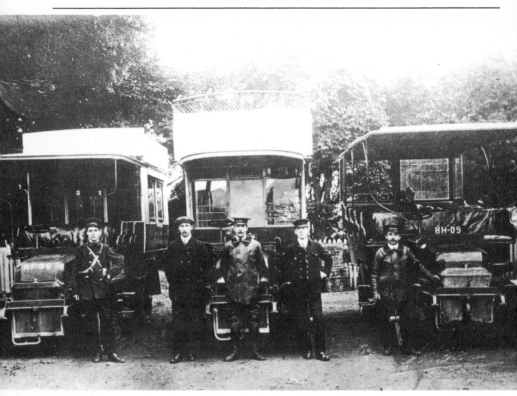

THREE TYPES OF GWR BUSES, all Milnes-Daimler vehicles, in Stroud station yard ready for service. Compare the left-hand vehicle with that in the previous photo – the same registration number but now with a boxed-in body.

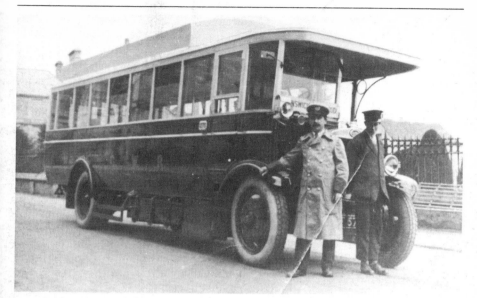

A LATER TYPE GWR BUS. A Guy on pneumatics. Taken in the 1920s at the Painswick terminus near the churchyard. The driver is S. Adams.

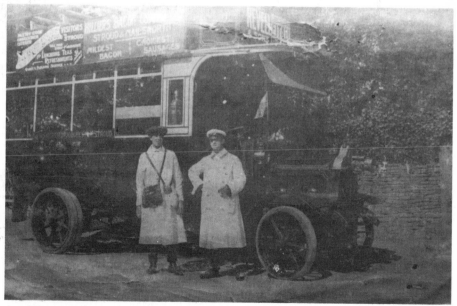

Arnold's ran a bus service from Nailsworth to Stroud. Their bus, pictured here, was a Coventry built Rykeneld vehicle. Conductor, Frank Cleaveley; driver, W. Close. Date – 1913.

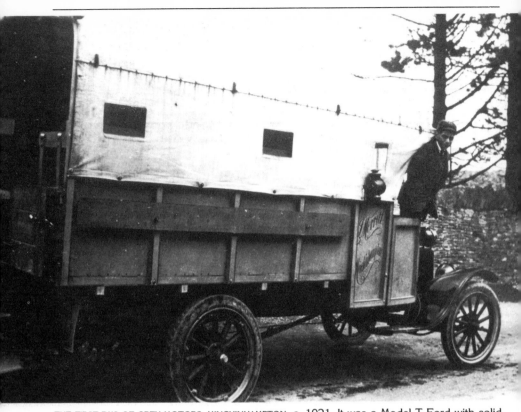

THE FIRST BUS OF GREY MOTORS, MINCHINHAMPTON, c. 1921. It was a Model T Ford with solid tyres on the rear wheels, entrance at the rear, and seats running the length of the body. The boy leaning out of the cab is Fred Merrett, the son of the proprietor.

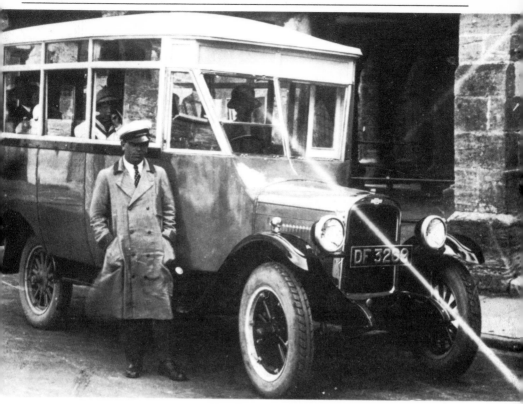

A LATER GREY MOTORS BUS, a 4-cylinder Chevrolet, outside the Market House, Minchinhampton, in the late 1920s. The driver is Arthur Hill. These vehicles had wooden-spoked wheels which had to be wetted periodically in dry weather to prevent shrinkage.

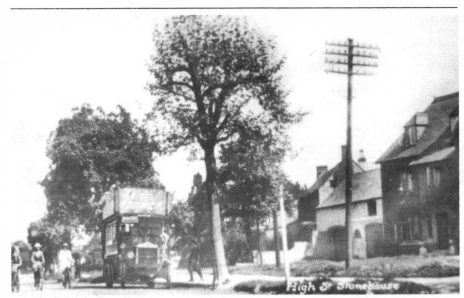

OPEN-TOP NATIONAL OMNIBUS CO. DOUBLE-DECK BUS on the Stonehouse–Chalford service at the Crown & Anchor stop in Stonehouse High St. in the 1920s. Are the young ladies about to race the bus?

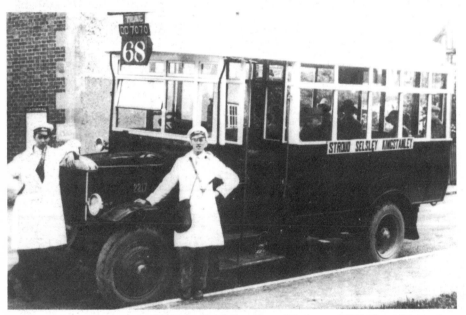

A NATIONAL BUS waits outside the Kings Head Inn, Kings Stanley c. 1927. The vehicle was a Guy and was one of the first National buses locally to be fitted all round with pneumatic tyres. Driver, Fred Blick; conductor, N. Curry.

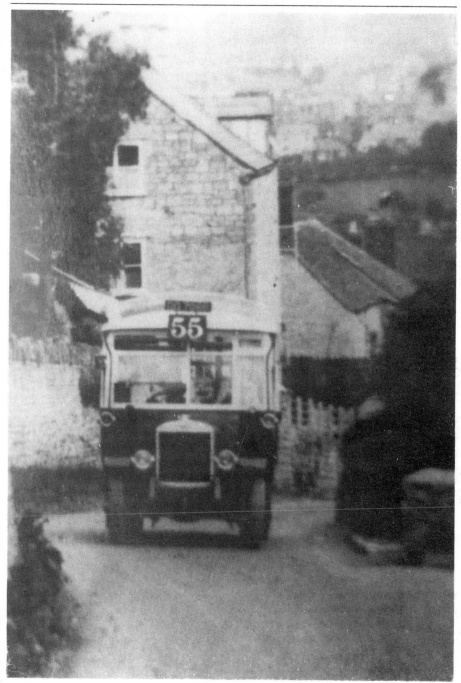

A SIMILAR NATIONAL BUS climbs Butterow on the Stroud–Minchinhampton service c. 1927.

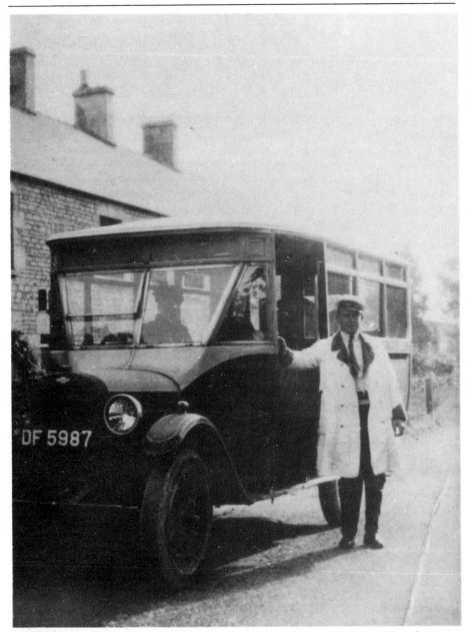

THE RED BUS CO. SERVICE, from Stroud to France Lynch, stopped by Jubilee Cottages, Brownshill, late 1920s. The vehicle is a 4-cylinder Chevrolet. The driver is Martin Smart who kept his bus, overnight, in his lime quarry at Chalford Hill. If the bus was heavily loaded, to enable it to climb the hill from Toadsmoor to Eastcombe, men and boys had to de-bus at the bottom and walk to the top where the bus waited!

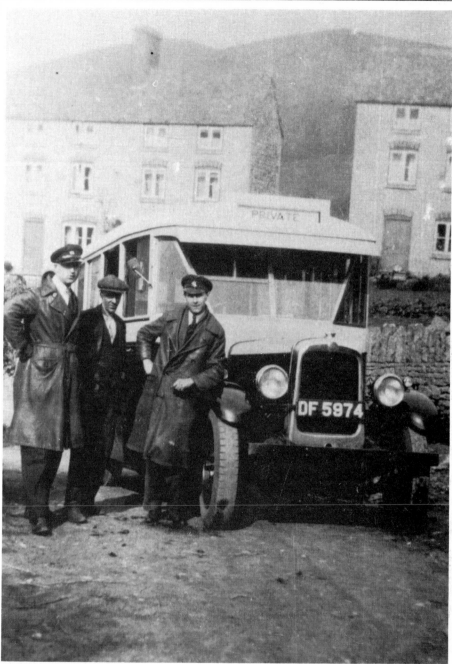

ANOTHER RED BUS CO. VEHICLE, a GMC – location not identified. Left: W. Bourne (driver). Right: C. Rudge (driver). Centre: Arthur Burrows (fitter).

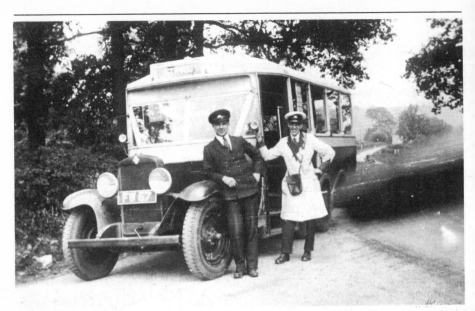

A RED BUS AT STANDISH LANE in the 1920s. It is a 6-cylinder, 6-wheeled Chevrolet, a vehicle which went well but was very difficult to stop as it had brakes only on one set of rear wheels. Driver, E. Wilkins: conductor, F. Bevan.

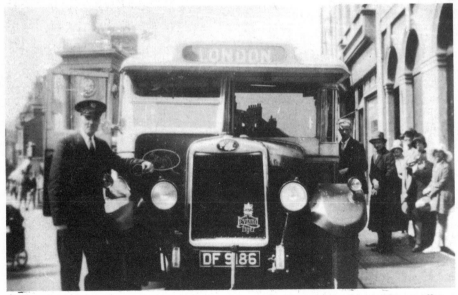

RED BUS CO. LEYLAND TIGER COACH on the London service outside the George Street offices, early 1930s. The service ran twice a day – 9 am and 3 pm with a 4-hour schedule. On the left, Inspector L. Grimmett. Note by his left arm the Kangaroo emblem of the Red Bus Co.

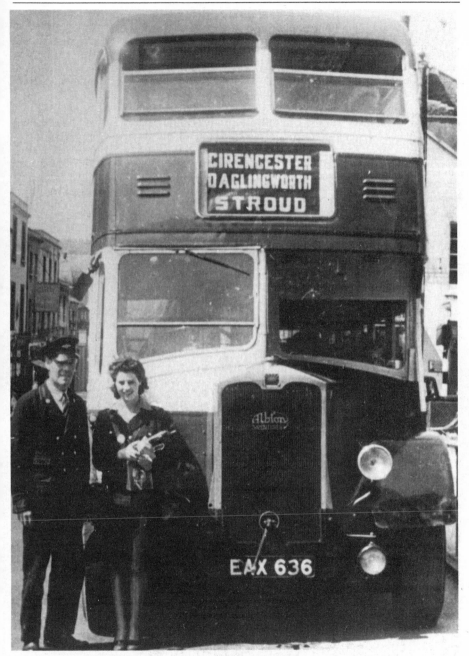

THE FIRST DOUBLE-DECKER to be used by the Red & White Bus Co. on the Stroud–Cirencester service waits at the bus stop outside the Subscription Rooms, Stroud. Driver – H. King; conductress – J. Pegler.

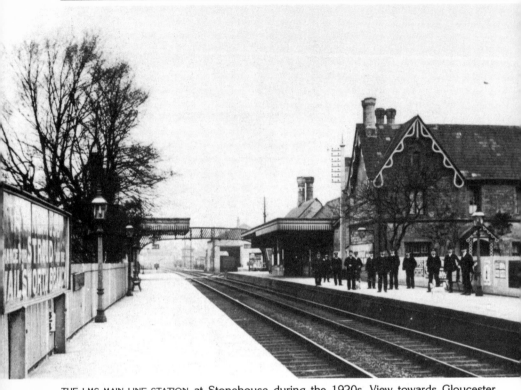

THE LMS MAIN LINE STATION at Stonehouse during the 1920s. View towards Gloucester.

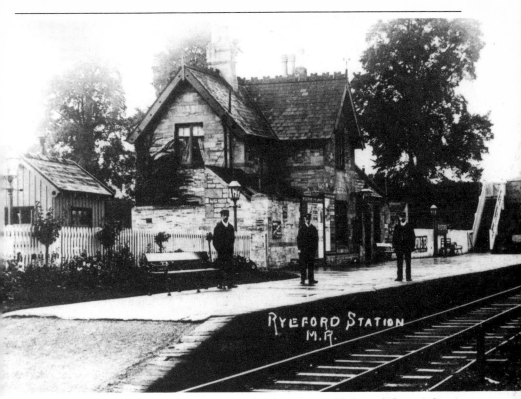

A WELL-CARED FOR MIDLAND RAILWAY STATION on the Stonehouse–Nailsworth branch line in 1905, now completely demolished. A new cycle track runs where the rails are here.

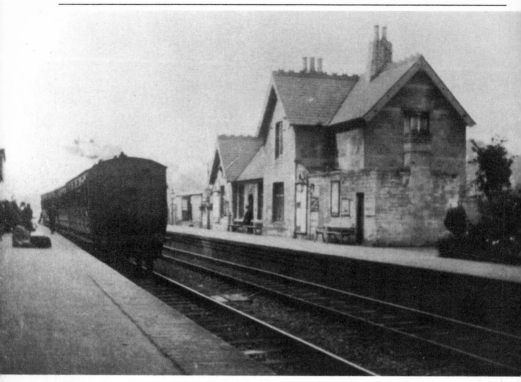

DUDBRIDGE STATION, possibly c. 1912. Midland Railway coaching stock. The building remains today.

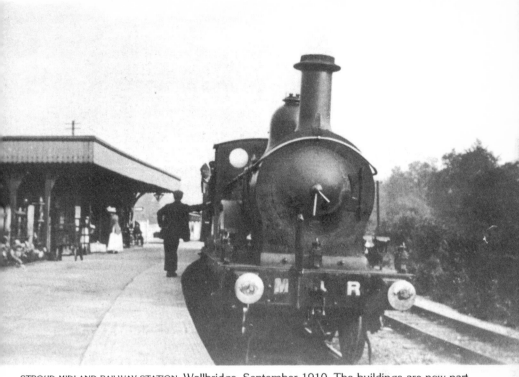

STROUD MIDLAND RAILWAY STATION, Wallbridge, September 1910. The buildings are now part of the small Industrial Estate.

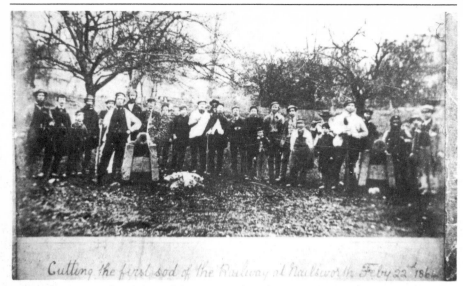

A VENTURE BEGINS in this picture of the cutting of the first sod of the Stonehouse–Nailsworth Railway at Nailsworth on 22 February 1864. The ceremony was performed by the local MP, E. Horsman Esq.

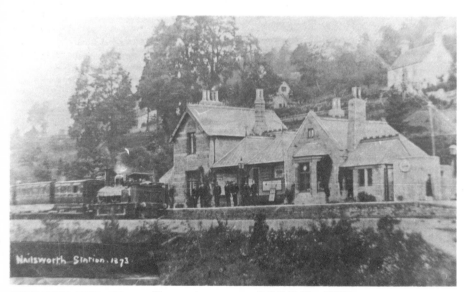

SEVEN YEARS AFTER OPENING. The engine was an 0-6-0 T No. 2008.

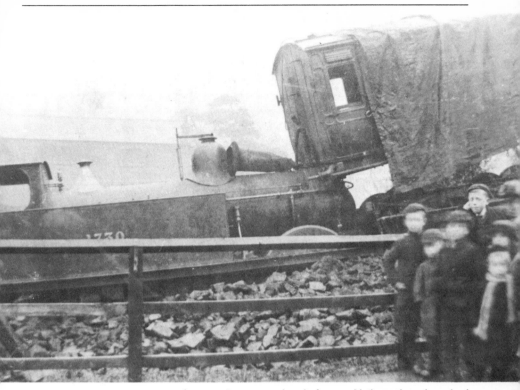

THE SCENE ON 22 DECEMBER 1892, when a train overran the platform at Nailsworth and crashed through the stopblock, some fifty yards beyond, dropping ten feet onto a heap of coal in the station yard. The only casualty amongst the ten passengers was a young lady named Tarrant, who broke her right leg. The driver said the rails were slippery, but he had not waited for a connection at Dudbridge, had no Guard, and passed through Nailsworth platform six minutes early.

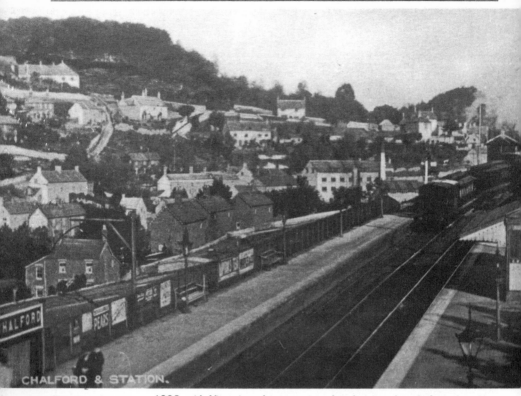

CHALFORD STATION, c. 1908, with Victorian clerestory coaches leaving the platform London-bound.

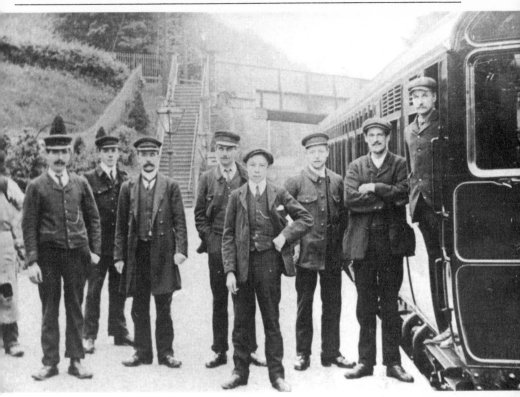

CHALFORD STATION STAFF assembled by the Rail Motor on the down platform, c. 1908. In the long coat, the Station Master, Mr. Pritchard. The man on the left in the torn sack apron is probably an employee of R.T. Smith, local carriers to the GWR.

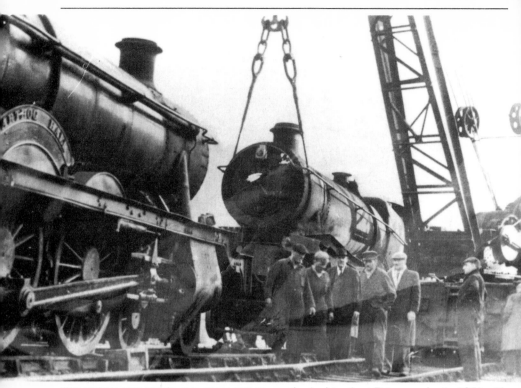

6993 ARTHOG HALL MEETS 4945 MILLIGAN HALL on the 'up' track at Brimscombe in 1961 with disastrous results. Both were heading goods trains. The latter, too long for the sidings, had been shunted onto the 'up' line to allow a passenger train through. The former passed three signals at danger before the collision.

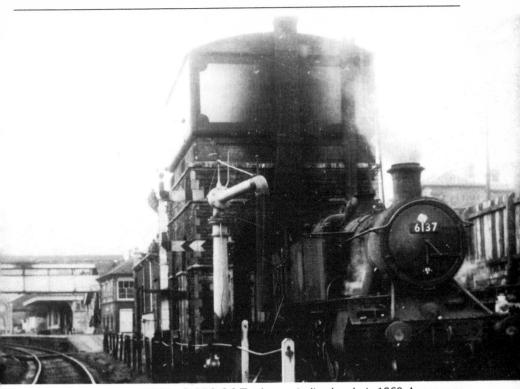

BRIMSCOMBE BANKER SHED with No. 6137 2-6-2 T at home, feeling lonely, in 1960. As many as three bankers were shedded here. The station and east signal box in the background.

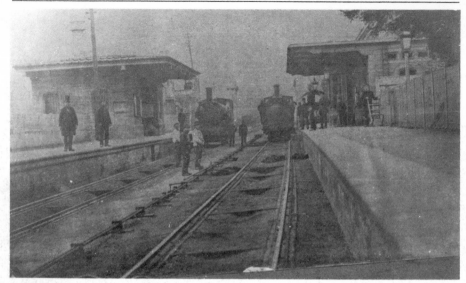

BRIMSCOMBE STATION, c. 1875–80. The width between the platforms, necessary for broad gauge track, is clearly seen, although the rails, still broad gauge style, were laid to standard gauge in 1872. The tall gentleman on the edge of the 'up' platform is Brimscombe's second Station Master, R.D. Woodyatt. The engines are clearly Saddle Tank Bankers.

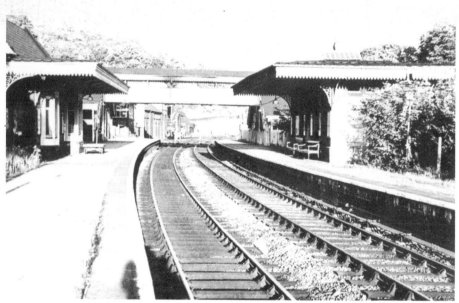

BRIMSCOMBE STATION from the west, 1950s. Originally Brunel built in 1845, it served as the station for the surrounding hill villages, as well as Chalford, until the latter's station was built in1897.

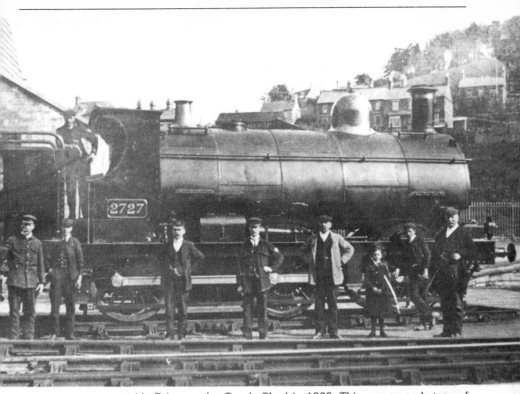

A 27 CLASS 0-6-0 ST outside Brimscombe Goods Shed in 1900. This was an early type of Brimscombe Banker. The class was built at both Swindon and Wolverhampton, but this engine was built at Swindon.

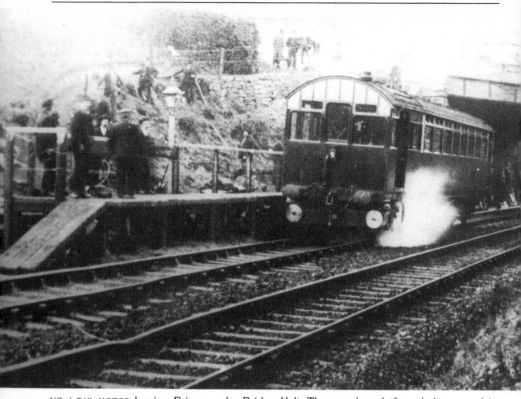

NO. 1 RAIL MOTOR leaving Brimscombe Bridge Halt. The wooden platform halt, opened in February 1904, was later converted to a brick-faced dirt platform. The Rail Motor is about to pass through the shortest tunnel on the GWR.

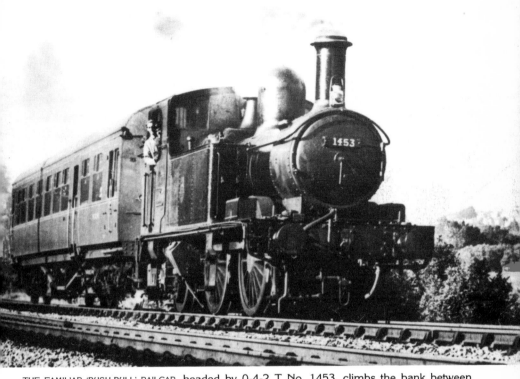

THE FAMILIAR 'PUSH-PULL' RAILCAR, headed by 0-4-2 T No. 1453, climbs the bank between Ham Mill Crossing Halt and Brimscombe Bridge Halt in 1960. Whilst the crew were lunching at Chalford after its previous run, an enthusiastic photographer had asked if he could clean the engine as he wished to take a photo of it, at this spot, on its next 'up' journey. Obviously the lunch break was not long enough for him!

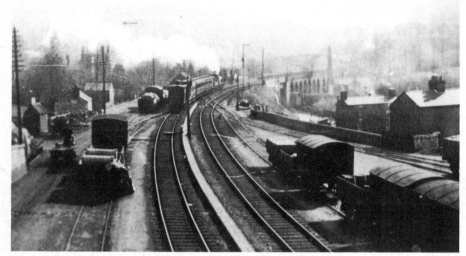

AN EARLY EDWARDIAN SCENE AT STROUD. A train of Victorian coaching stock is about to cross Capels Viaduct going east. The small wagons in the foreground have been said to be of the type used to carry explosives.

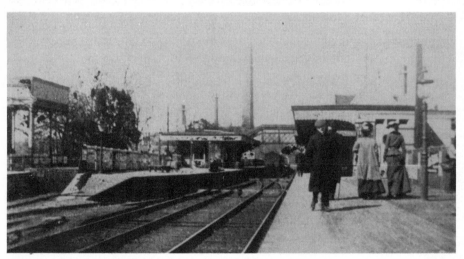

STROUD GWR STATION, 1902, showing the original short down platform and the cross-over between the main lines.

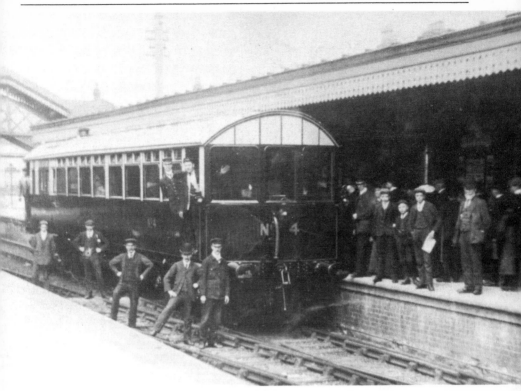

NO. 4 RAIL MOTOR at Stroud 'up' platform, c. 1904. This was one of the original ones on the Chalford–Stonehouse service. The engine is seen facing Gloucester, a procedure which was reversed in 1905.

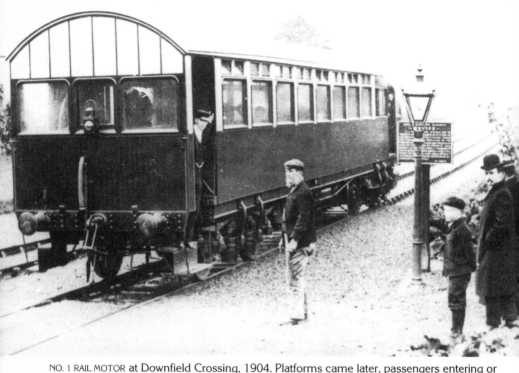

NO. 1 RAIL MOTOR at Downfield Crossing, 1904. Platforms came later, passengers entering or leaving the car by means of folding steps operated by the Guard.

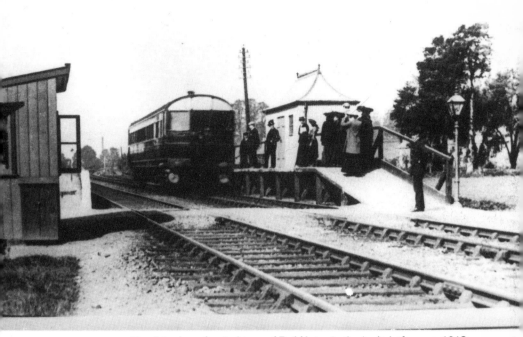

EBLEY CROSSING HALT with a later bow-fronted type of Rail Motor in the 'up' platform, c. 1912. The 'pagoda' shelters were quite a feature of the halts. The building on the left was the ticket office.

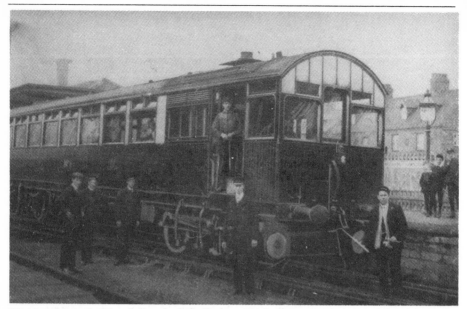

NO. 1 RAIL MOTOR in Stonehouse 'up' platform in 1904. Additional windows have been added above the main windows in the driving cab as it was found that drivers had to stoop to see out of the main windows. Nos. 1 and 2 Rail Motors were withdrawn from service in the valley towards the end of 1904 as they were found to be under-powered. They were sent to the Lambourn Valley Railway.

SECTION FOUR

Industry

The majority of the mills in the valleys originated with the woollen trade. Some very old mills started as corn mills, later becoming woollen mills – some vice versa and then back again. As the woollen trade declined many converted to silk throwing, though some were built for this specific purpose. As this trade declined so the buildings began to be used for a variety of industries such as general engineering, pin making, walking stick, carpet, paint, plastics and car manufacture, printing and wood carving. Thus many of these old mill buildings have survived and, even now as those secondary uses have declined, they are being adapted as modern industrial estates.

The following selection of photographs give a few glimpses of this branch of history in the valleys.

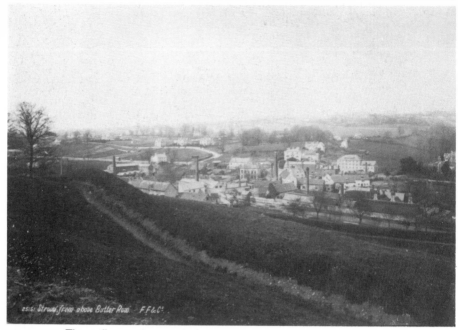

BOWBRIDGE. The mill complex c. 1910, with the canal wharf middle right. Few of these buildings remain. The tall four-storey building (middle right) was burnt down twenty-five to thirty years ago when used for a wood-working business. it is now the site of Webb's haulage business.

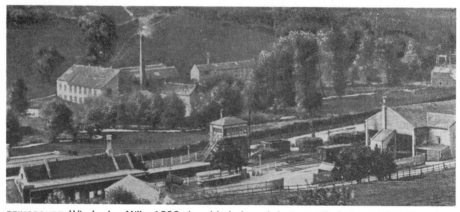

BRIMSCOMBE. Wimberley Mills, 1898. An old cloth and dyeing mill, then a stick mill until, in 1883 Critchley Bros. opened their pin manufactory here. Many of the old buildings remain amidst the modern complex. Extreme right: the gasometer of Brimscombe Gas Works. Foreground: Brimscombe station with the, then, only signal box, at the west end of the down platform. There were thirty steps up to this box.

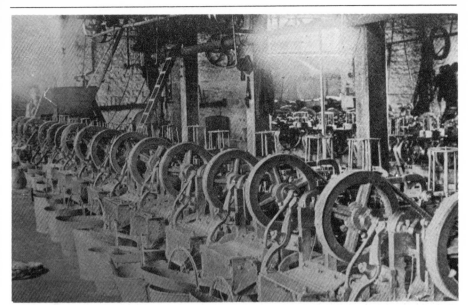

BRIMSCOMBE. Some of the pin-making machinery in Wimberley Mill, 1898

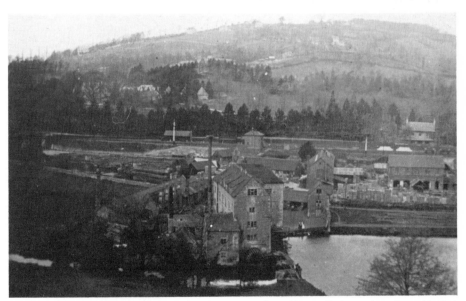

BRIMSCOMBE. Dark Mills, c. 1900. It was then a wood-working mill, in conjunction with that across the canal where Olympic Varnish is today. The business was owned by Philpotts (nicknamed Lord Sawdust). Dark Mills was purchased by Critchley Bros. in 1906 and demolished in 1964. Behind and to the left of the mill is the entrance to the dry docks of the Bourne Boatyard.

FROM **H. S. HACK**
WHOLESALE UMBRELLA STICK MANUFACTURER
BOURNE MILLS, BRIMSCOMBE, GLO

GW&LMS RLYS

CGK 929

A COLONIAL CONSIGNMENT OF UMBRELLA STICKS LEAVING THE WORK

BRIMSCOMBE. Bourne Mills in 1935, still called Hacks Mill and now having a number of small businesses and a car-breakers. Young Mr. Hack, in plus-fours stands near the first lorry. The rival G.W. and L.M.S. railways sank their differences in this area and ran a combined carrier service.

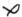

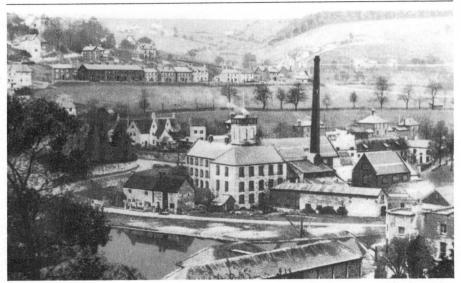

BRIMSCOMBE. Port Mills, c. 1910. One of a group of mills worked by the Evans family, relatively intact today as part of Bensons. The two-storey buildings at the side of the basin are the canal lengthman's cottage and the salt store. The field above the mill is the Jubilee field, now developed as the Victoria and Albert Road council estate.

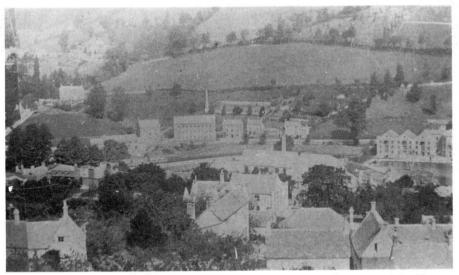

BRIMSCOMBE, 1873. Centre right: the headquarters building and warehouse of the Thames and Severn Canal, later to become the Polytechnic. The three-storeyed building (centre left), with the detached chimney some way to the rear, is a silk mill built by the Evans family. Today it is a terrace of shops and houses, called Gordon Terrace. The building to the left was the Mill manager's house and is now the Post Office. The building to the right was the Port Inn.

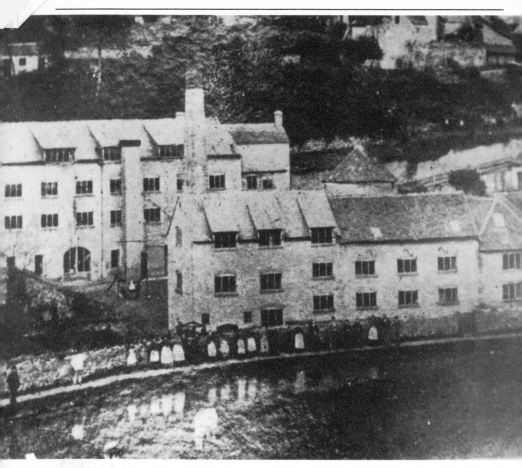

CHALFORD. Sevilles Mill c. 1860, with some of the work-force on the canal towpath. One of Chalford's oldest mills where the last woollen cloth in the village was made. It was demolished about thirty years ago to be replaced by several modern units. Note the conical roof of the round drying tower and to its left, part of the Anchor Inn.

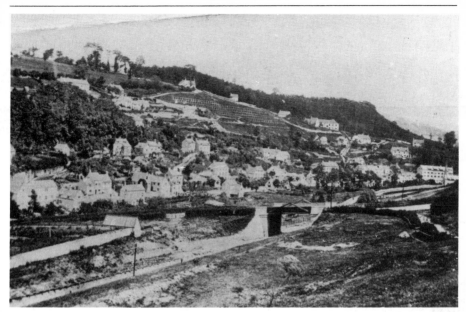

CHALFORD, 1860. The chequer pattern on the hillside is made by the cloth racks of Sevilles Mill (extreme right centre). The wooden railway bridge takes the Stroud-Cirencester Road over broad gauge track.

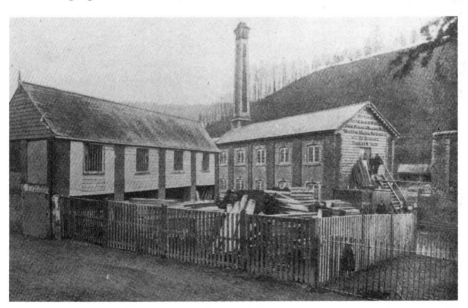

CHALFORD. Victoria Steam Joinery Works in 1897. Built in 1871, gutted in 1906, and subsequently rebuilt, it is now the factory of Chalford Chairs. The timber drying shed and yard, on the road island, was replaced by an air-raid shelter in the Second World War.

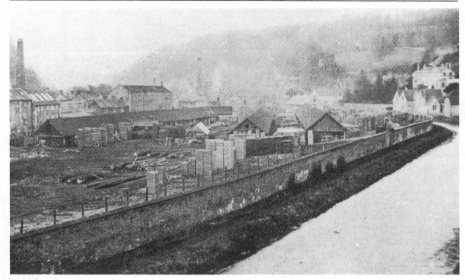

CHALFORD. The present day Chalford Industrial Estate as it was in 1897 when it was still carrying on Dangerfields walking stick and wood and bone turning business. There were five mills on this site.

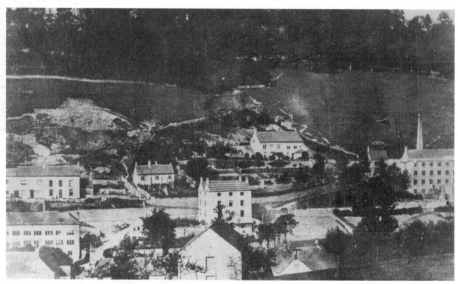

CHALFORD. A view in 1873 from Hyde Hill. Lower left, the four-storey Clayfields Mill. The large gable ended building (lower left centre) is Iles or Grists Mill, a flock mill, burnt down c. 1913 and now demolished. Both mills were water driven at this time. Centre right is the Victoria Silk Mill, the chimney being detached some distance behind. Early this century it was converted to ten two-storey flats called Victoria Cottages. About 20 years ago it was renovated as eight dwellings.

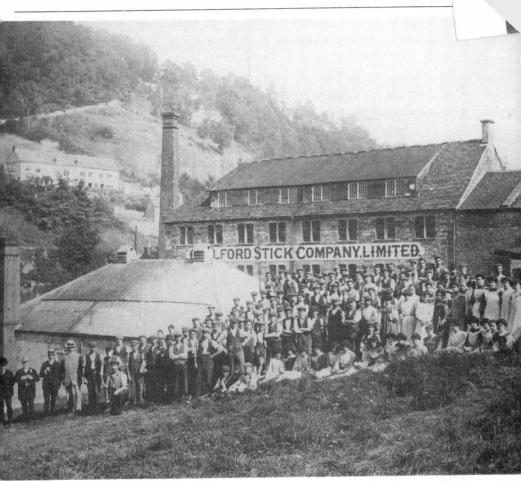

CHALFORD. St. Mary's Mills, c. 1905. The work-force of Chalford Stick Co. at the rear of the mill. W.C. Dann, the owner, third from the left. The business continued under various owners until 1981 when it was moved to North Woodchester. In 1983 Mr. Martin Neville started another walking stick manufactory here.

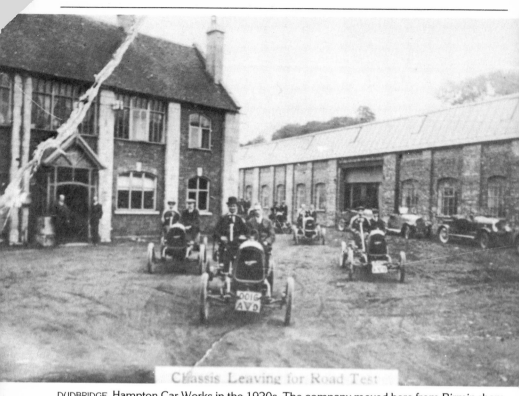

Chassis Leaving for Road Test

DUDBRIDGE. Hampton Car Works in the 1920s. The company moved here from Birmingham to the present Cope Chats site. Some of the bodies were built at Belvedere Mill, Chalford.

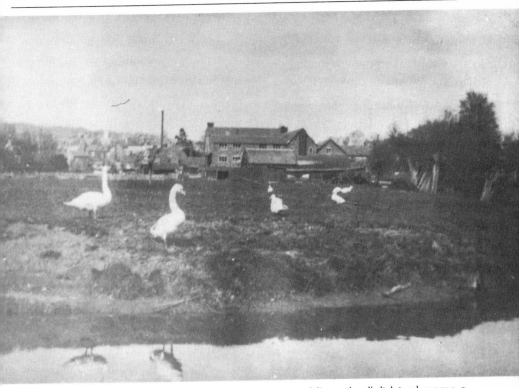

EBLEY. Oil Mills, c. 1930. Built in 1731 to make 'rape and linseed oyl'. It later became a woollen mill but by 1840 was a corn mill, for which purpose the majority of its buildings are used today.

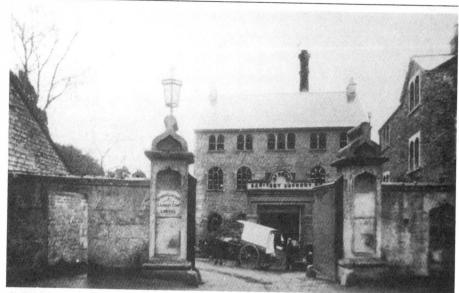

EBLEY. Stroud Sanitary Laundry, 1902, in which 'no work of an undesirable kind received'. The premises and drying ground were leased from Sir William Marling of Ebley Mills and continued to provide a service to the Stroud District until after the Second World War.

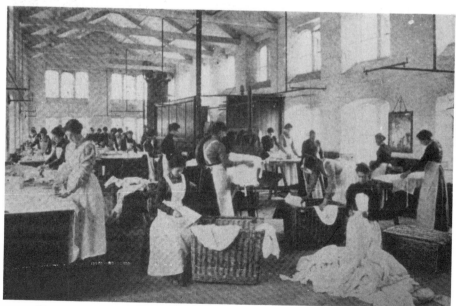

EBLEY. The interior of the upper floor of the Laundry.

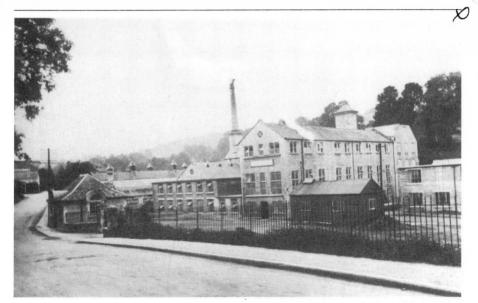

LIGHTPILL. Lightpill Mills, early 1920s. The name board on the east wall of the North Mill is Erinoid Ltd., the trade name of the second oldest of the modern plastics materials first made in this old mill in 1911, under the trade name Syrolit. The name was changed to Erinoid in 1914, after bankruptcy. The factory was closed in 1982 and is now the Bath Road Trading Estate. In 1911 Frederick Steele, printers, occupied the loom sheds (conical capped vents).

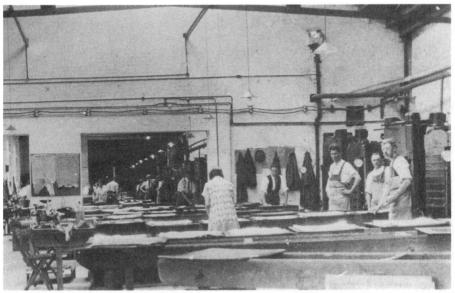

LIGHTPILL. The interior of the Press Shop, Erinoid Ltd., mid-1920s. The presses were manufactured by T.H. & J. Daniels Ltd. of Bath Road, Lightpill.

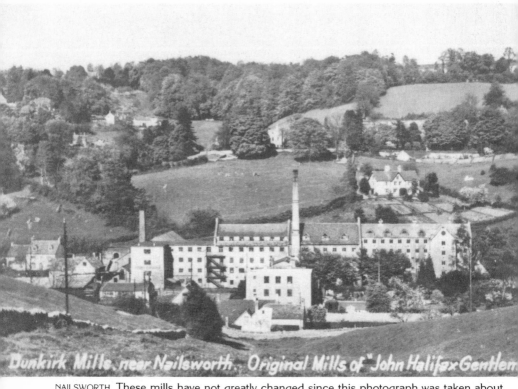

Dunkirk Mills, near Nailsworth. Original Mills of "John Halifax Gentlem...

NAILSWORTH. These mills have not greatly changed since this photograph was taken about forty-five years ago. From 1891, for many years, W. Walker & Son Ltd. manufactured hosiery here, as well as walking sticks. Around 1960 a large portion was used by John Critchley for his D.I.Y. Stores – Critchcraft.

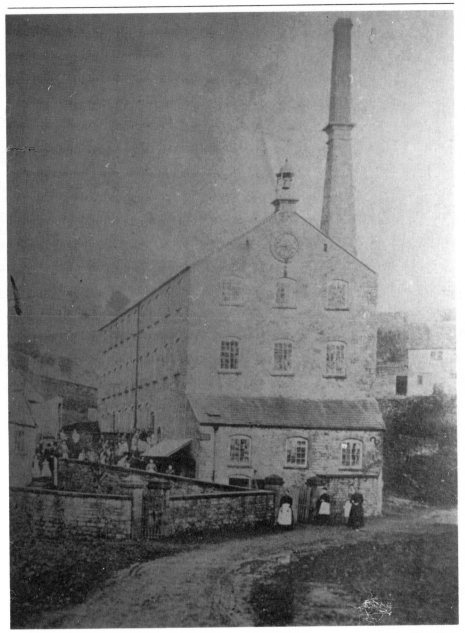

OAKRIDGE. Possibly an 1880 view of the Silk Mill which stood at the junction of the Broadway, the Whiteway and the lane descending from the Methodist Chapel. An unusual sight in a hill village but built here c. 1845 to provide local employment. Coal for the steam engine had to be brought up from the canal wharf at Bakers Mill Lock by pack donkeys. Closed in 1890, sold in 1897 and demolished soon after.

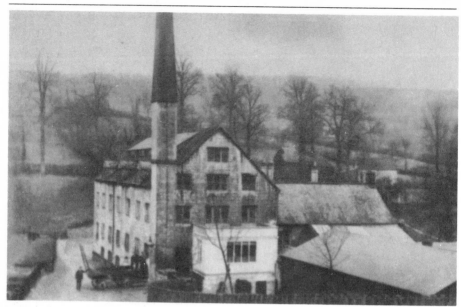

PAINSWICK. Knapps Mill, c. 1900. Later owned by Reeds and then taken over by Savory's for pin-making where it became the last of the pin factories in the district.

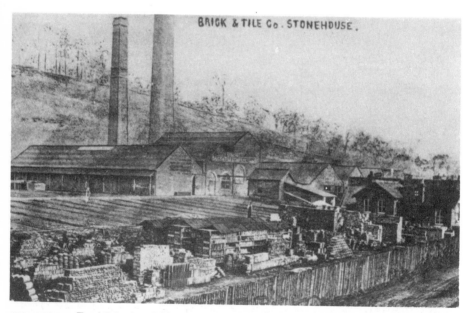

STONEHOUSE. Established in 1890. This photograph is thought to be 1900–1910. Stonehouse had two brickworks, this one near the G.W.R. Station, the other, that of Jefferies, being nearer Ebley.

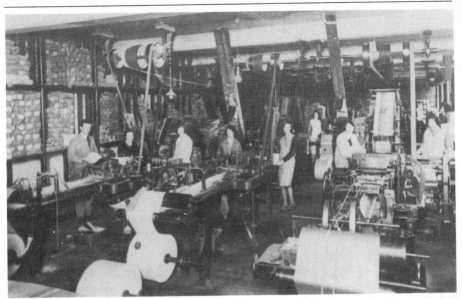

STONEHOUSE. The interior of the Sack & Bag Works at Lower Mills about the Second World War period.

WOODCHESTER. Employees of Bentley Piano Works which occupied Woodchester Mill. The photograph is thought to have been taken in the 1920s.

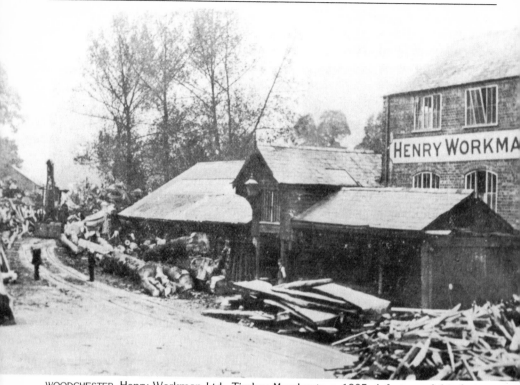

WOODCHESTER. Henry Workman Ltd., Timber Merchants c. 1905. A feature of this factory was the steam cranes which not only ran on the factory's own lines and across the Stroud–Nailsworth Road to their storage yard, but also used the Midland Railway line which passed through the rear of the factory. Quaker Chemicals Co. occupies the site today.

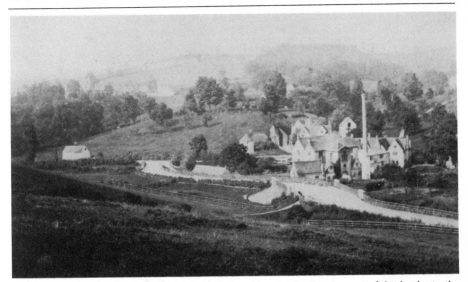

WOODCHESTER. Southfield Mills, pre 1900. The railway bridge is now part of the lay-by to the new road. The round drying house is unique today. To the left of the chimney stack is a small building with a frontage which looks alien to a Cotswold woollen mill. It was a pin mill used by the partners Perkins, Critchley and Marmont before 1883. The pin mill was taken down and re-erected in Bodnant Gardens near Conway, North Wales, where a plaque affixed to it describes its history.

WOODCHESTER. Pre 1900, probably soon after Newman Hender & Co. had opened their engineering works here. The mill pond is now covered with the buildings of Hattersley-Newman and McEvoy.

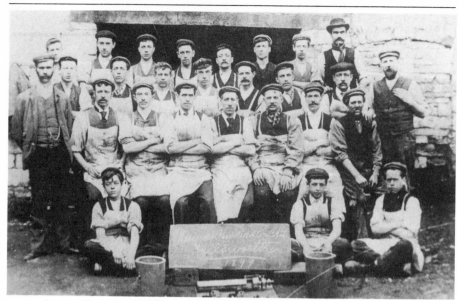

WOODCHESTER. Newman-Henders workforce in 1899.

SECTION FIVE

Water

The whole district abounds with natural springs which formed the source of water for many of the villages and towns. In the lowland areas, wells, often fitted with pumps, had to be dug to tap the underground water. Wells were also common in the hill villages.

As early as 1744 an attempt was made to provide Stroud with piped water, but with no success until 1769. The copious springs at Chalford East were tapped c. 1870 and a pumping station and treatment plant erected in Marley Lane. This supplied water to reservoirs at Minchinhampton, first at the Blue Boys and then where the reservoir is today. The pumping station was moved further west to Belvedere Mill in Chalford, in the early 1920s, where it is today. Since the war many of the old springs and wells have been condemned, the water being deemed 'unfit for drinking'. Strangely most domestic animals still prefer it to the piped supply!

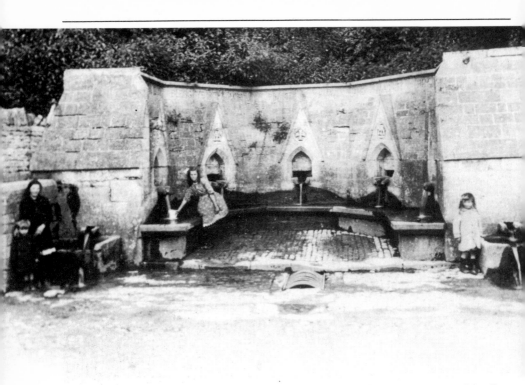

BISLEY. The Seven Springs, the source of the Toadsmoor Stream, as restored by Rev. Thomas Keble Snr. in 1863.

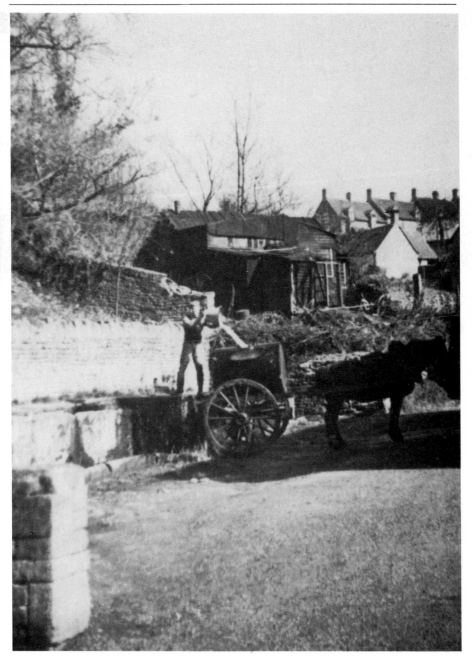

BISLEY. Another, not so well known, section of the Bisley Springs, c. 1920. Here, one of the local farmers (believed to be either Skinner or Stephens) is filling the farm water cart. The building behind is the smithy of Mr. Davis.

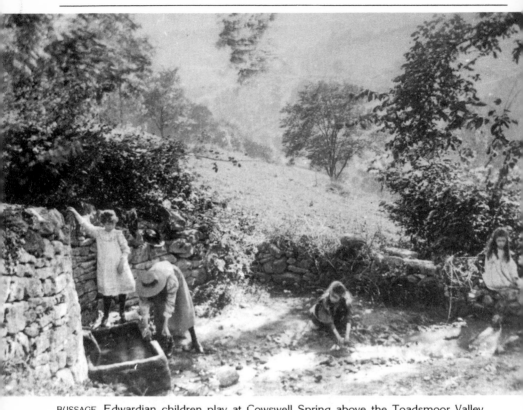

BUSSAGE. Edwardian children play at Cowswell Spring above the Toadsmoor Valley.

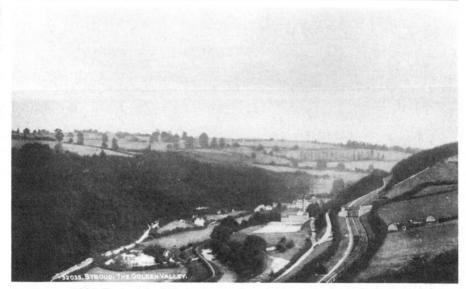

CHALFORD, c. 1900. To the left of Marley Lane railway bridge is the original Chalford Pumping Station. The white area in front is the settling tanks. Lime from these was pumped across the canal to the white area on the left, now part of the Recreation Ground. Beyond the chimney, the buildings of Ashmeads Mill.

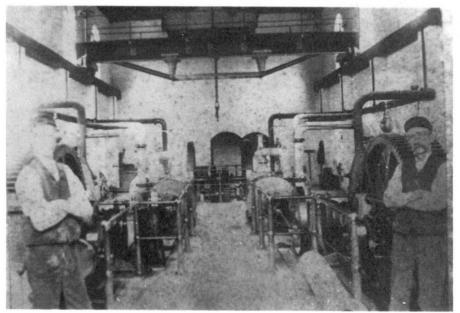

CHALFORD. The interior of the Pump House, c. 1920. Fred Hale (left) and his father, George Hale (right.)

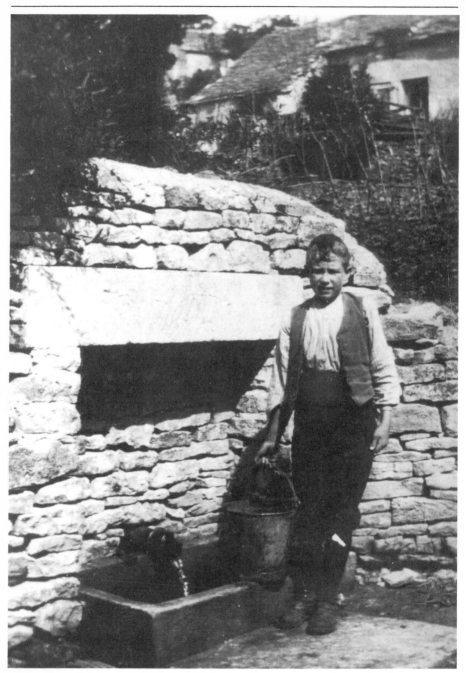

FAR OAKRIDGE. Drawing water early this century from the spring below Iles Green House, where Lord Robertson, Chairman of British Rail in the 1960s, lived.

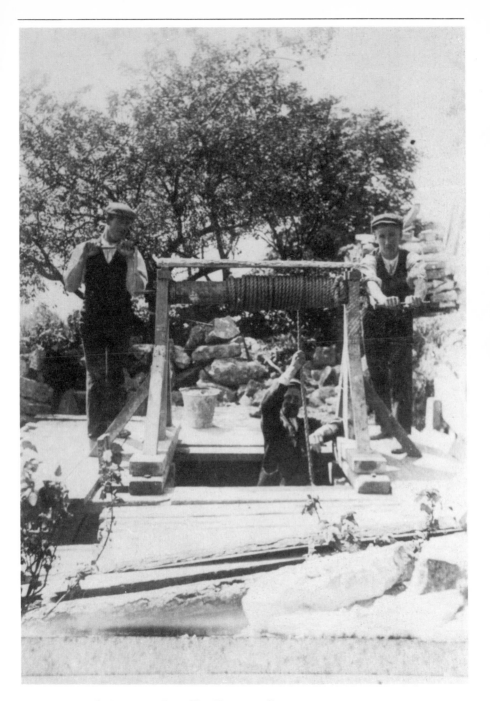

FRANCE LYNCH. Sinking a well at 'The Homestead'.

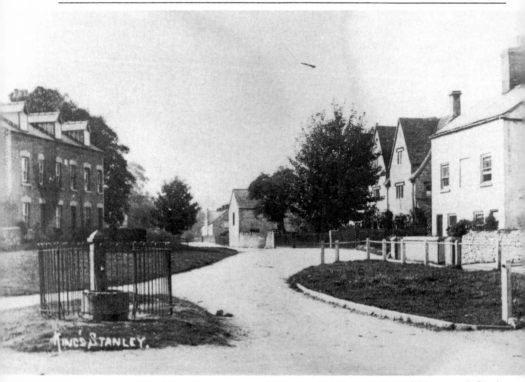

KINGS STANLEY, 1910. The village pump which stood at the junction of Shute and Castle Streets.

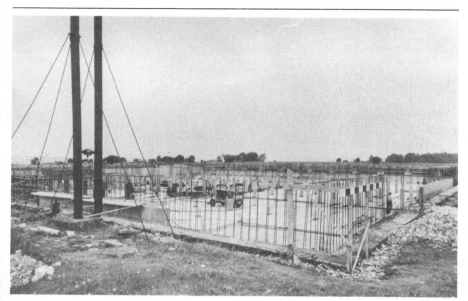

MINCHINHAMPTON. Believed to be construction work in progress for the present reservoir (1960s) on the Amberley Road. The one which it replaced was the first, built in about 1880 and enlarged in the mid thirties. The tall U-pipe was a feature of this reservoir and provided a head of water for The Lodge.

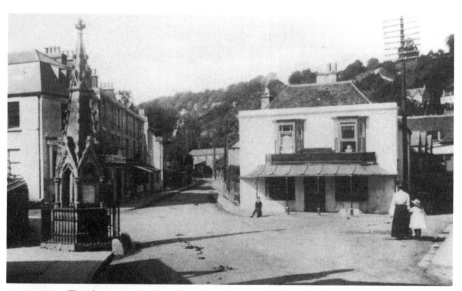

NAILSWORTH. The fountain in it's original position, c. 1905–12. 'Erected here in 1862 as a memorial to the late William Smith, Esquire . . . who was an upright lawyer, a peace maker, an affectionate relative, a friend to all.' The fountain now stands in Market Square, by the bus terminus.

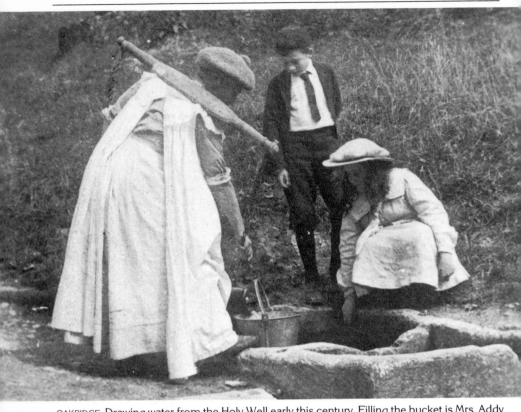

OAKRIDGE. Drawing water from the Holy Well early this century. Filling the bucket is Mrs. Addy and she uses the yoke to make carrying easier.

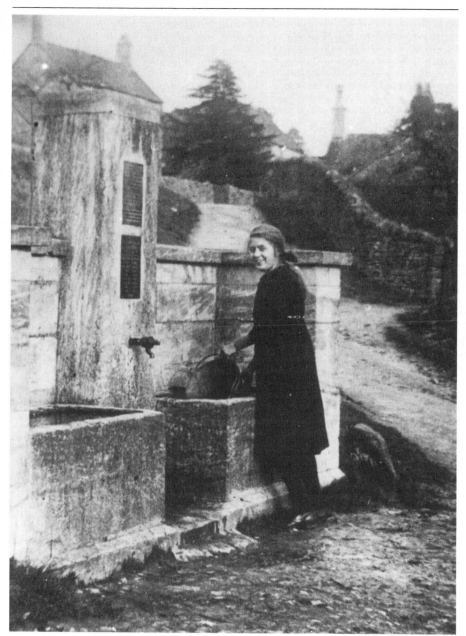

OAKRIDGE, early 1920s. The Dearmer memorial, about 100 yards above the Holy Well, was erected after the first World War: 'In memory of Mabel Dearmer who went from Oakridge, the place she loved best, to give help in Serbia where she died of fever at Kragujevatz, on July 11th, 1915 aged 43 and of Christopher Dearmer, who died of wounds at Sulva Bay in Gallipoli on October 6th, 1915, aged 21.' Picture shows Miss Iris Restall drawing water.

STROUD. The Dolphin Fountain at The Cross, 1935. The street decorations are for the Silver Jubilee. The Stroud Co-op Headquarters Stores, opened in 1931, behind. A deep well of water here was originally covered by a stone building housing the public pump. By 1780 it was disused and the building had become a lock-house, called the Blind House, with a set of stocks behind. This was demolished by 1811. In 1839, the well was deepened and fitted with a new pump which was very difficult to use so that, in 1866, it was converted to the drinking fountain.

SECTION SIX

Breweries and Inns

Was it the copious water supply, or did the woollen industry create a thirst, for breweries seemed to be a common feature of the area. In addition, directories of the last century indicate that most villages had numerous small alehouses brewing their own beer. Of those breweries shown here – though an incomplete record – only one remains in a reasonably intact state. The selection of inns is, of necessity, limited.

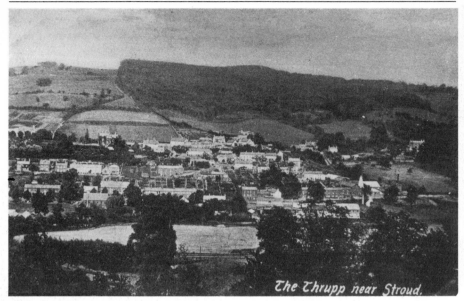

The Thrupp near Stroud.

THRUPP, C. 1905. The white building, middle right, is the Brimscombe brewery of Smith & Sons. The building at the bottom of Brewery Lane, occupied until recently by National Tyres, is all that remains. The brewery was closed in 1913. A steeplejack was killed whilst demolishing the chimney in 1919 for the Chess Brand Rubber Co. of Brimscombe.

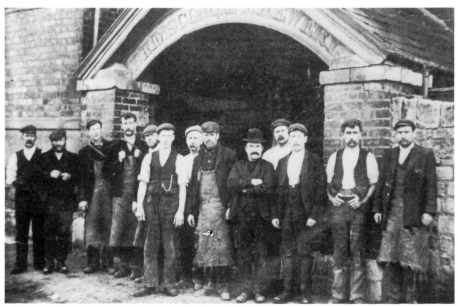

A GROUP OF EMPLOYEES outside the brewery in 1913, prior to closure. Fourth from the left is Bill Fisher, who became a drayman for Stroud Brewery Co.

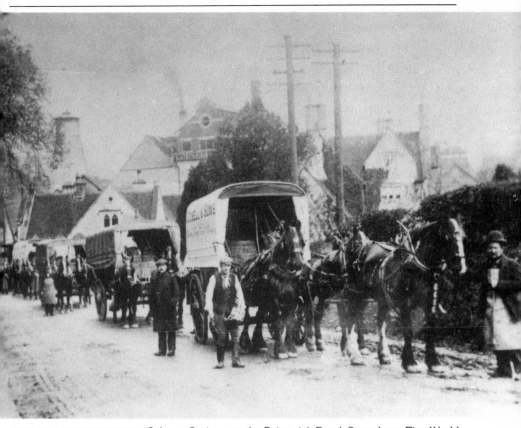

GODSELL & SONS BREWERY at Salmon Springs on the Painswick Road, Stroud, pre First World War. A selection of their delivery drays is drawn up for this photograph. The buildings have remained relatively intact and are part of the Salmon Springs Industrial Estate.

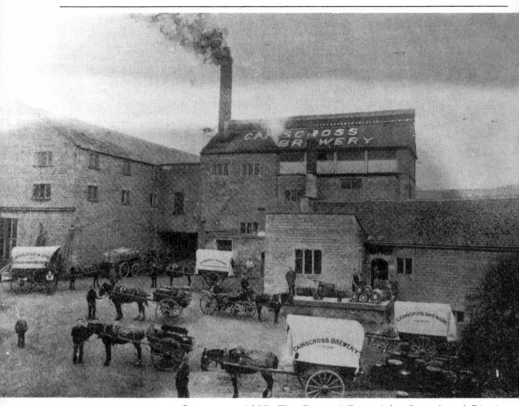

CARPENTERS BREWERY at Cainscross, 1897. The Pictorial Record for Stroud and District (1904) says that the brewery had no tied houses and produced a fine beer. The building on the left remains as the Coronation Hall.

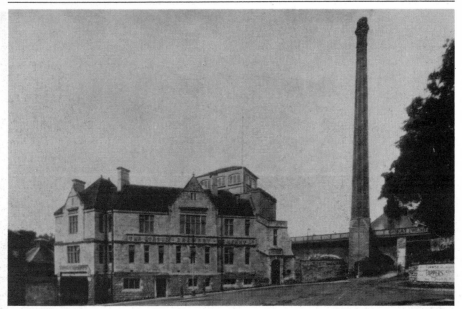

STROUD BREWERY OFFICES, *c.* 1925. Built *c.* 1900, together with the chimney, by W.F. Drew of Chalford.

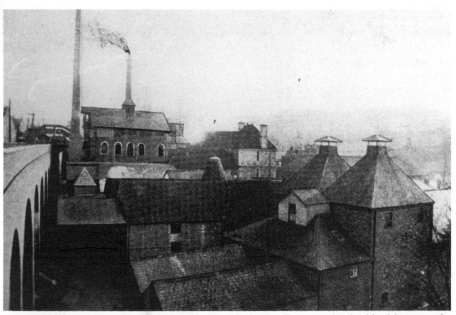

STROUD BREWERY from The Hill, Merrywalks, 1902. The Brewery also had buildings on the opposite side of the Cainscross Road used as a bottling department. All were demolished in the 1970s.

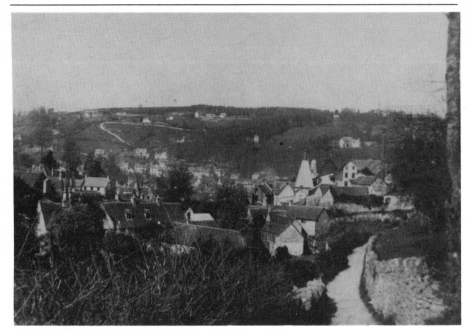

A VIEW OF NAILSWORTH from the Bristol Road showing the brewery buildings of Clissold & Sons, middle right. The scene is pre 1900.

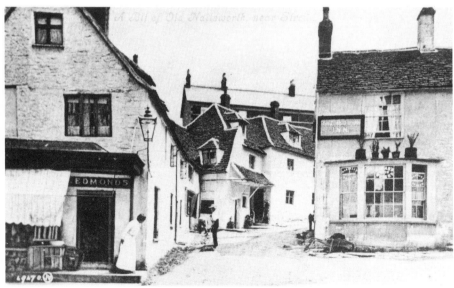

NAILSWORTH. The Red Lion Inn at the junction of Market Street (left), Brewery Lane (right) and Butcher Hills Lane, c. 1905. The inn is now Avening Cottage.

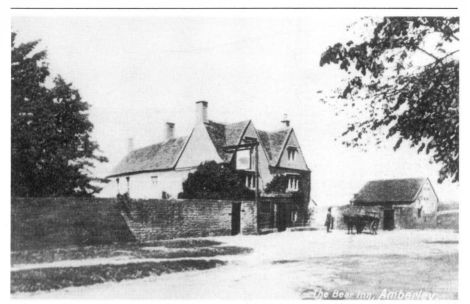

AMBERLEY. The well-known Bear Hotel as it was c. 1900. Around 1800 it was the practice of the common-carriers of wool, cloth etc. to site their stables and warehouses near the inn. The goods from the valley mills were brought up to the warehouses by pack-horse and donkey, for trans-shipment in the wagons.

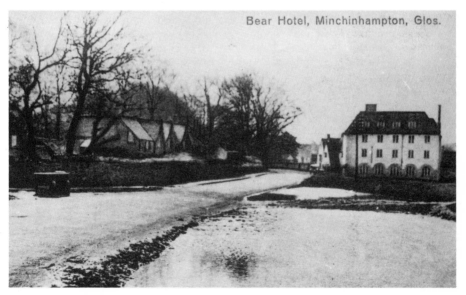

AMBERLEY. The Bear Inn after the extensions to make the Hotel. In the foreground are the drinking pools for the cattle. These gave their name to the adjacent café and garage.

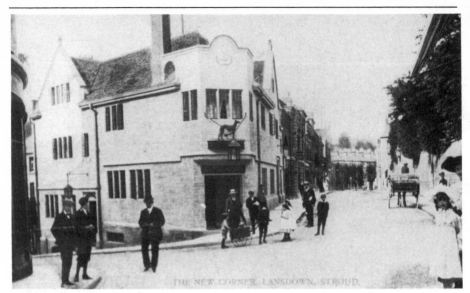

STROUD. The Greyhound Inn, 1904–5. The caption 'New Corner' indicates that this frontage of the Greyhound was a new feature. Previously a small rectangle of ground was between the inn and the Lansdown Road. This came onto the market in 1903 and its purchase enabled the Greyhound frontage to be altered to this shape.

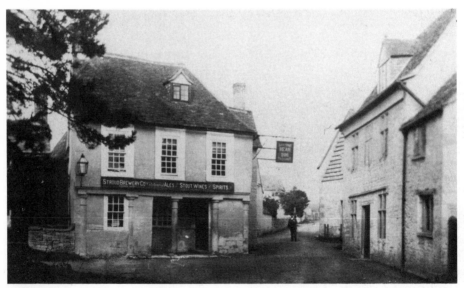

BISLEY. The Bear Inn, c. 1912. A small cobbler's shop occupied some space between the pillars. This inn was formerly the Manorial Court House and Assembly Room, the Bear Inn then being the house on the right. The façade with the pillars is Jacobean and is an enlargement of the Tudor building behind.

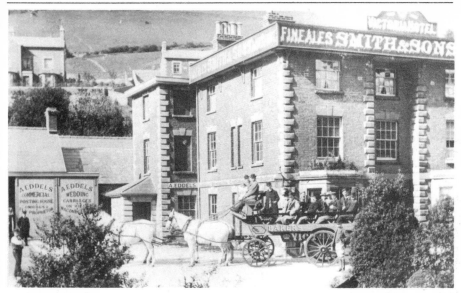

BRIMSCOMBE. The Victoria Hotel, c. 1895, then a Brimscombe Brewery house. The landlord, Eddles, ran the Chalford–Stroud and Stroud–Stonehouse horse-buses from here and in addition, hired out horse-charabancs, waggonettes, wedding carriages etc., for local outings. A day's outing from here would have been to Framilode, or Westonbirt Park.

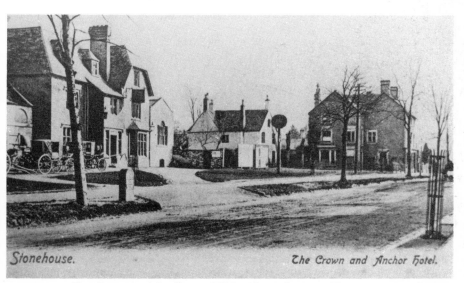

STONEHOUSE. The Crown and Anchor, c. 1900, with a selection of horse carriages for hire. Note the milestone for Gloucester and Stroud.

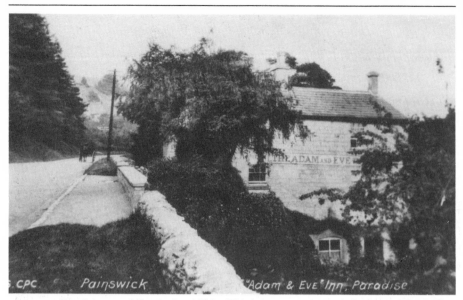

PAINSWICK. The Adam and Eve in the 1920s. This became a very popular inn on the A46 as car ownership increased. It closed a few years ago.

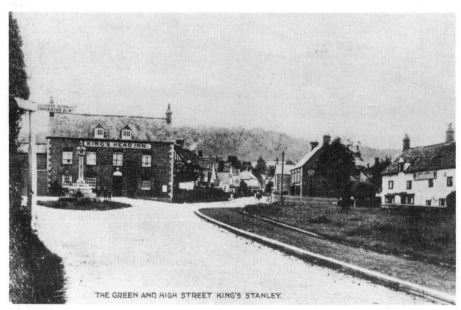

KINGS STANLEY, 1925. Only the Kings Head Inn remains of the two shown in this photograph, being a very popular inn today. On the right is the older Red Lion Inn, which closed in the 1970s.

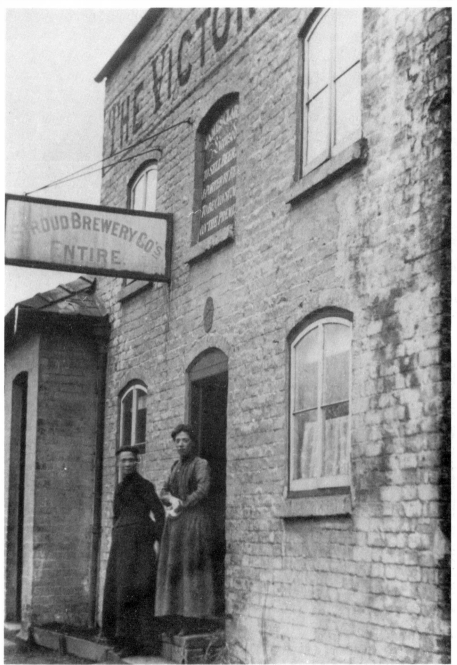

DUDBRIDGE. The Victoria Inn which fronted the canal towpath above Dudbridge Lock. Mrs. Clarke and daughter, Anne.

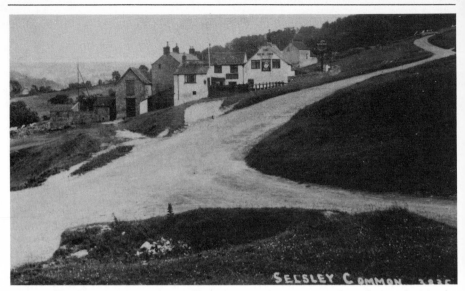

SELSLEY. The New Inn, now closed. The photograph appears to have been taken in the 1920s. The Stroud Brewery sign below the name had the caption 'As clear as a Bell'.

Occasions

A reason can always be found for a jollification, such as Sunday School Treats, Carnivals, Outings, Fairs or even more serious happenings, such as Openings, Dedications and Celebrations. Stroud and the Valleys were never short of these occasions as the following photographs show.

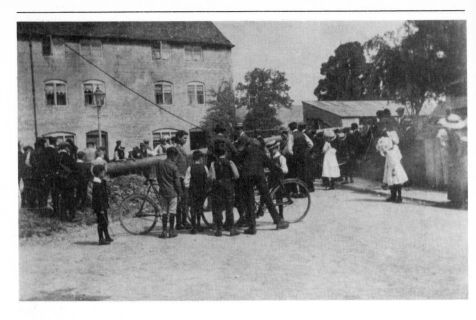

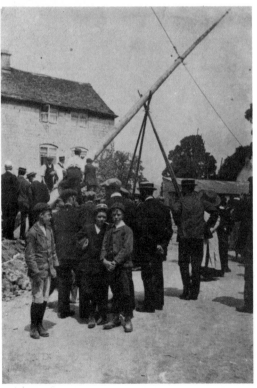

THE ERECTION OF THE MAYPOLE at Paganhill, early this century. Always an occasion for sightseers, helpers and numerous 'foremen'. The Maypole has been a feature of Paganhill for years. Each Whitsuntide it would be embellished. Periodically it had to be taken down for re-decoration, re-erection usually being a Saturday afternoon job. The present Maypole was erected for the 1977 Silver Jubilee.

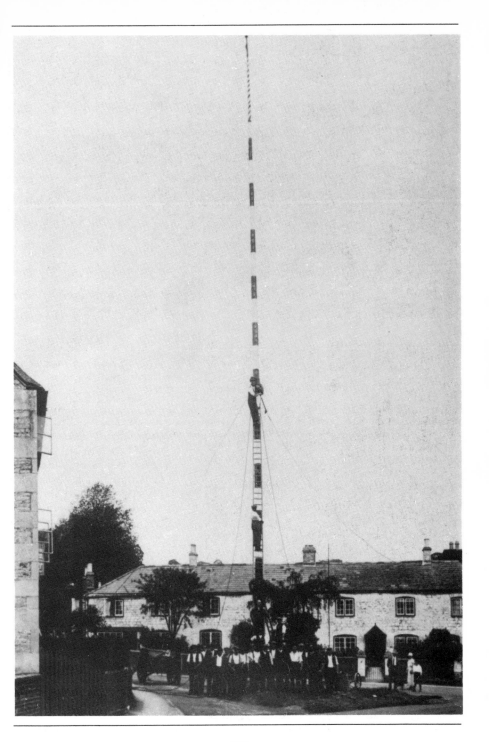

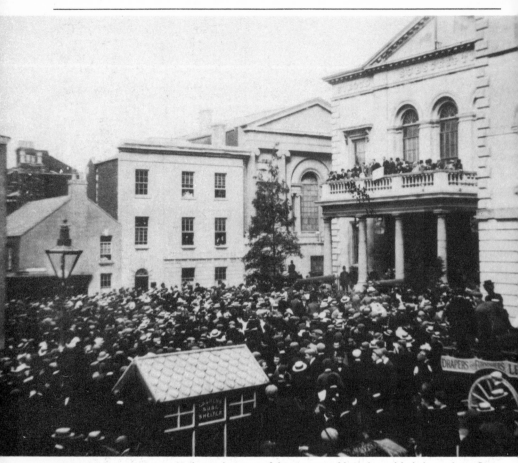

DECLARATION OF THE POLL in the early years of this century. Note the cabby's hut, where Sims Clock is today, and the two Crimean War guns on the forecourt.

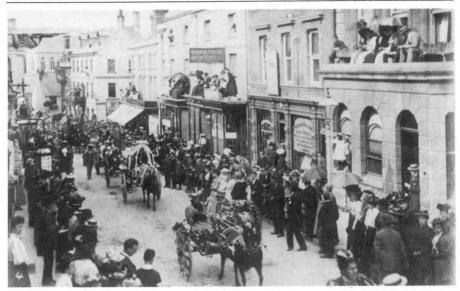

A DECORATED CARRIAGE PROCESSION in George Street, Stroud prior to a fête in honour of the election of C.A. Cripps as Stroud M.P., 31 August 1895.

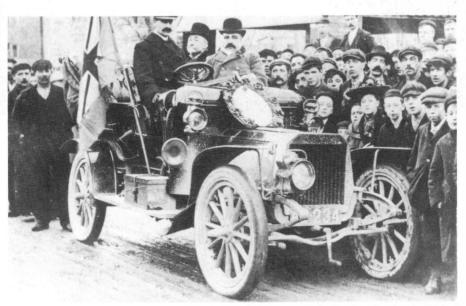

READY FOR A POST ELECTION TOUR for Charlie Allen (in bowler hat) after his election as Stroud M.P., possibly 1910. Behind him, Sir Alfred Apperley. Mr. Charles Apperley is the driver. Taken outside Dudbridge Mills. The horse-shoe plaque was usually a yellow silk emblem made by the girls employed at the mill.

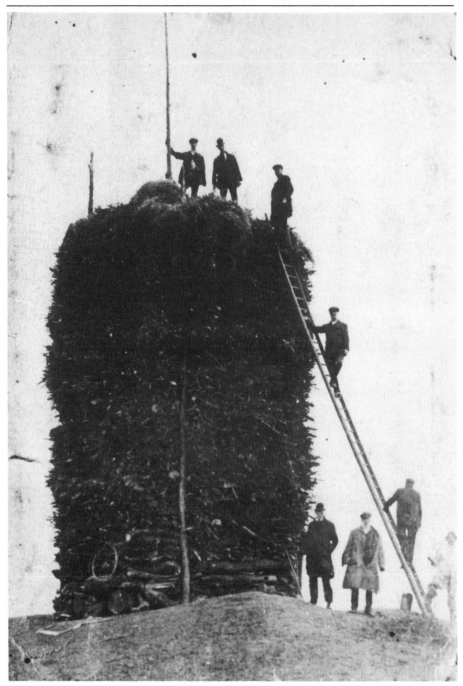

THE SELSLEY BEACON ready for the George V Coronation celebrations of 1911.

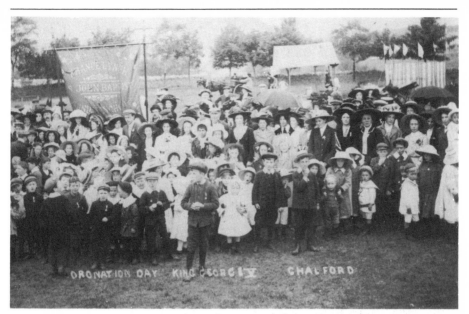

CHALFORD VILLAGERS at the France Lynch Recreation Ground for the George V Coronation celebrations of 1911.

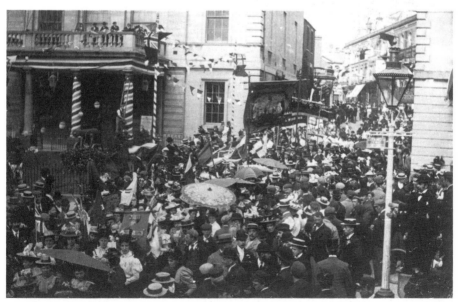

A PARADE IN KENDRICK STREET, STROUD, to mark the Diamond Jubilee of Queen Victoria. The Castle Street Sunday School banner aloft.

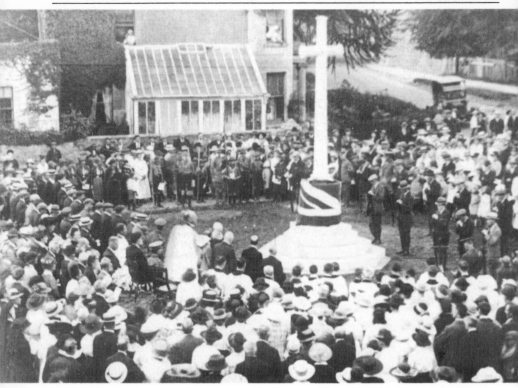

DEDICATION OF STONEHOUSE WAR MEMORIAL by the vicar, Rev. R.P. Waugh, 14 August 1919.

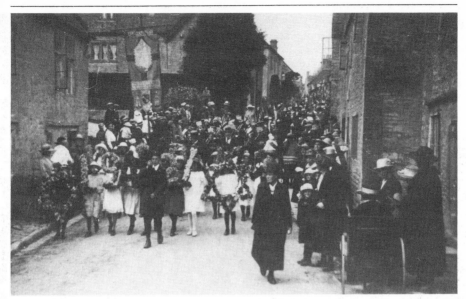

A 'DRESSING OF THE WELLS' PARADE passing down Bisley High Street on Ascension Day, 1912.

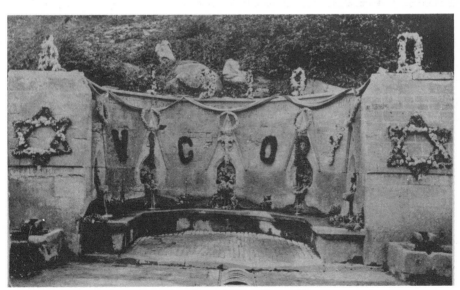

BISLEY WELLS dressed on Ascension Day, 1919 – Peace Year.

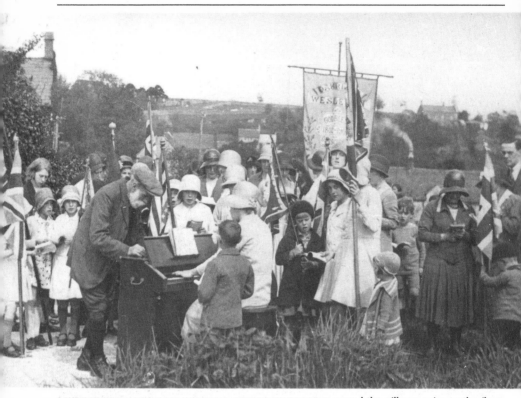

OAKRIDGE METHODIST SUNDAY SCHOOL WHITSUNTIDE PARADE round the village, prior to the 'bun fight', in the 1920s. It was the custom to carry the portable harmonium to accompany the hymns sung at various stops. John Peacey, methodist leader in the village for many years, leans over the harmonium. One of his daughters will be the organist.

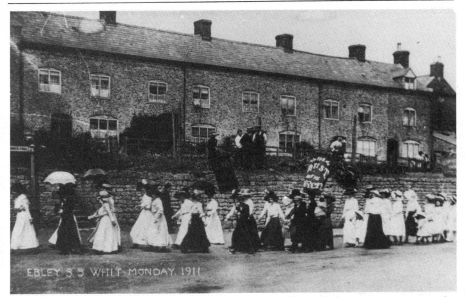

EBLEY SUNDAY SCHOOL PARADE passing from the main road into Foxmoor Lane en route for the tea.

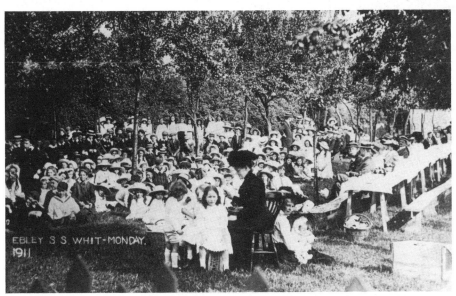

AFTER THE PARADE, THE TEA, believed to be in what is now Victory Park. The boy in the dark suit above 'Whit' is R. Hook. The elderly man (second on the right hand table) looking at the camera, is John Jacobs, Pastor of Ebley Chapel for fifty years. The young lady sitting behind the chair with the baby, her youngest daughter, is Mrs H. Davis, the baby now being Mrs B. Cook of Whiteshill.

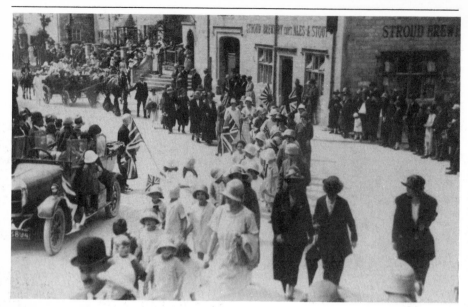

A RODBOROUGH CHURCH SUNDAY SCHOOL TREAT en route to the Fort, passing the Prince Albert, 1926.

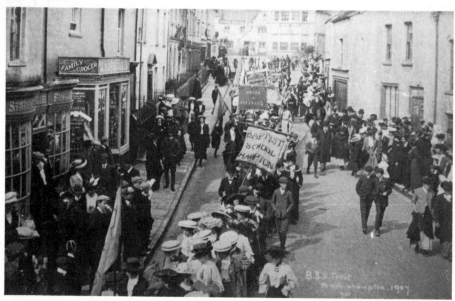

MINCHINHAMPTON BAPTIST SUNDAY SCHOOL TREAT, Whit Tuesday 1907. The parade, here seen passing down the High Street, would have been led by the Town Band.

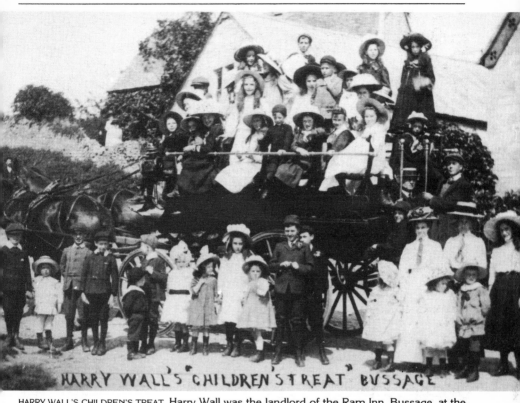

HARRY WALL'S CHILDREN'S TREAT. Harry Wall was the landlord of the Ram Inn, Bussage, at the beginning of this century. Each year he would take the village children for an outing and a picnic tea in one of his waggonettes. This party is outside the Ram, ready to go, in 1910. The lad on the left, with the top hat and post horn is his son, Jack.

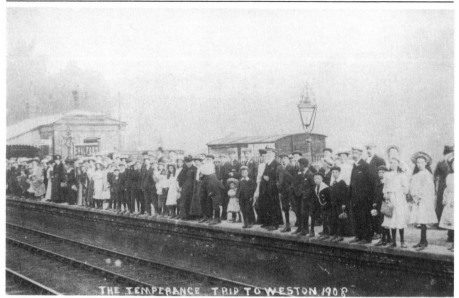

THE TEMPERANCE TRIP TO WESTON, 1908. The trip was organised by Chalford Baptist Chapel on August Monday of each year up to the Second World War. It was started by Mr J.H. Smart, the local coal merchant – a staunch Baptist and teetotaller – to take the village children away from the 'wild orgies' of Chalford Feast. Here the crowd wait for the special train at Chalford Station.

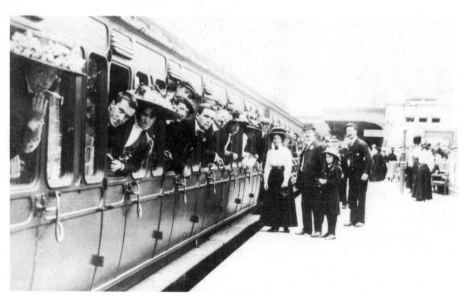

AN UNKNOWN OUTING from Stroud station early this century. It may have been one of the outings organised by the Stroud News.

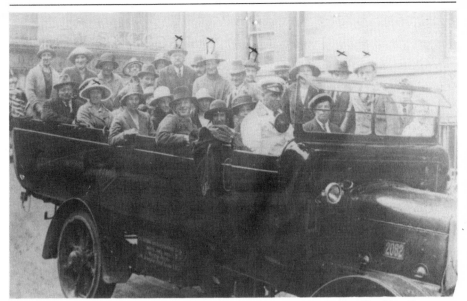

A PARTY FROM BISLEY about to descend Rowcroft, Stroud, en route for Cheddar Caves anu Weston, c. 1925. Driver, Valder King. National charabanc with bench seats across the vehicle, one door per seat on the near side. Solid tyres for a good ride!

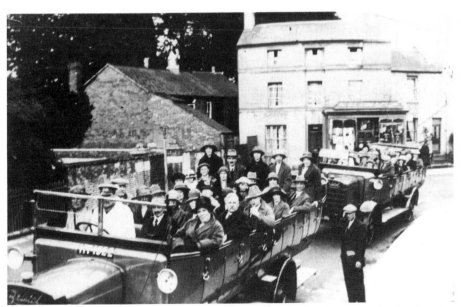

AN EBLEY OUTING near Townsend's shop (present day) waiting to go, in the 1920s. Two Bristol Tramways charabancs.

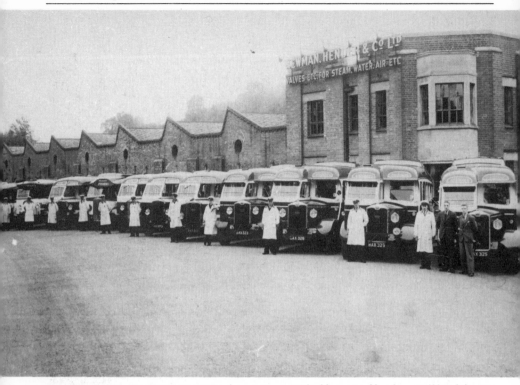

A FLEET OF RED AND WHITE COACHES drawn up outside Newman Henders at Woodchester ready for the Works outing to Weymouth on 5 June, 1937.

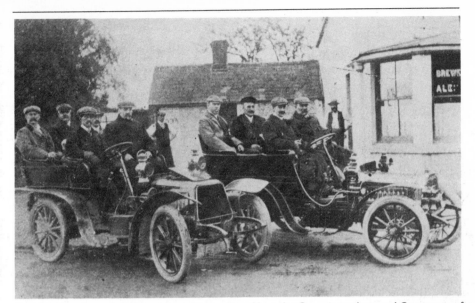

Even the local constabulary enjoyed an outing. Here the Superintendent and Sergeants of Stroud Police Division are on their outing to Weston on the 30 August 1905. But they have only reached the Brewer's Arms at Stonehouse.

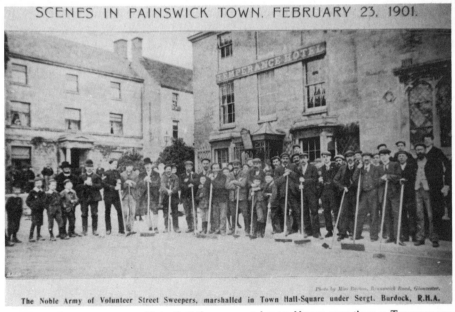

SCENES IN PAINSWICK TOWN. FEBRUARY 23. 1901.

The Noble Army of Volunteer Street Sweepers, marshalled in Town Hall-Square under Sergt. Burdock, R.H.A.

A D.I.Y. EFFORT AT PAINSWICK. Note that the present Lamp House was then a Temperance Hotel.

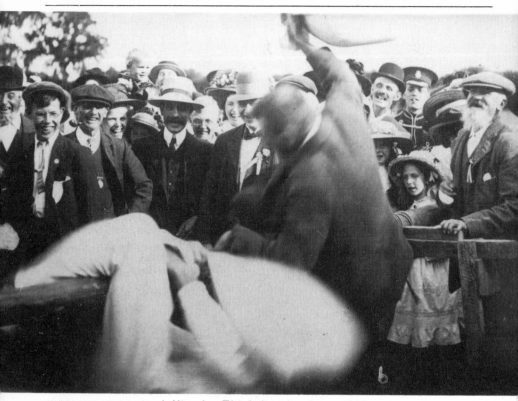

WHO'S WHACKING WHO? A Miserden Fête believed to be c. 1930.

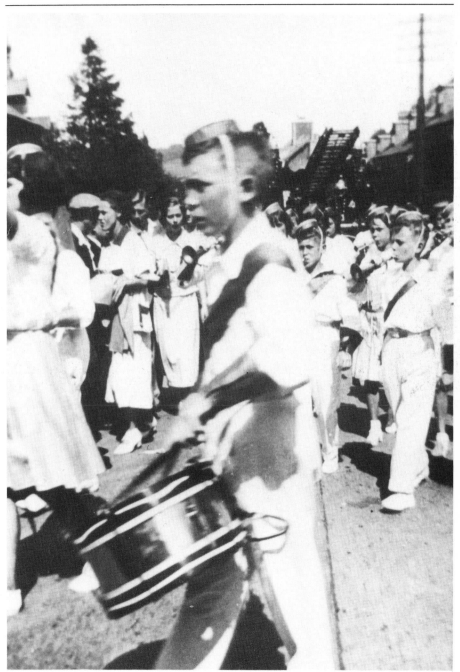

A 1930s JAZZ BAND in the Stroud Show Procession turning into Fromehall Park from the Bath Road.

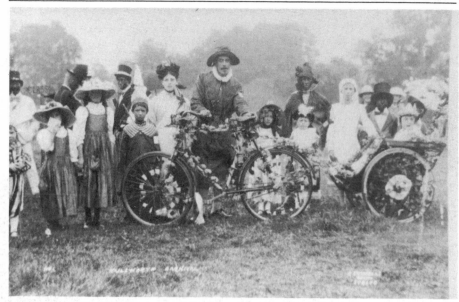

SOME NAILSWORTH CARNIVAL ENTRIES. Thought to be pre-First World War.

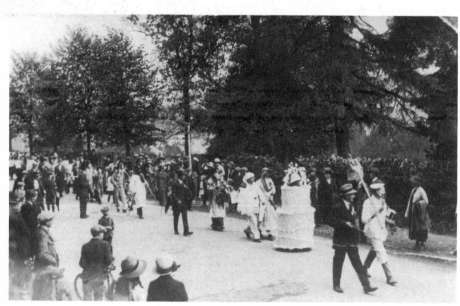

A CAINSCROSS HOSPITAL CARNIVAL PROCESSION, thought to be in the early 1920s.

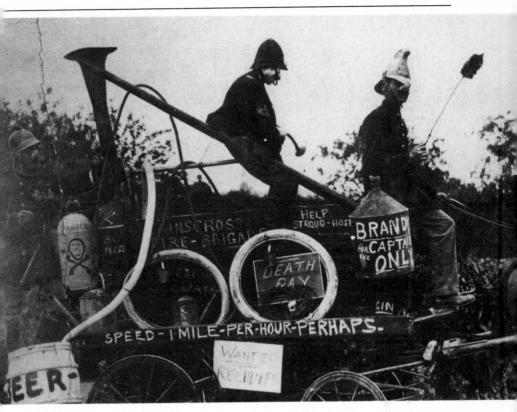

A CARNIVAL ENTRY.

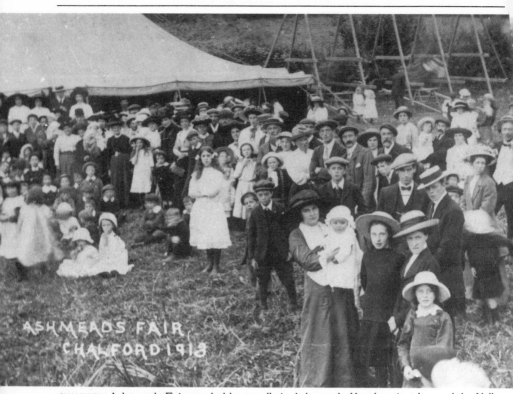

CHALFORD. Ashmeads Fair was held annually in Ashmeads Meadow, just beyond the Valley Playing Fields, to maintain certain winter grazing rights on the field. This picture shows some of those attending the last fair but one, before the start of the First World War. A meeting in June 1915 resolved not to hold the fair again until the 'boys' returned home. The fair was renewed in August, 1919.

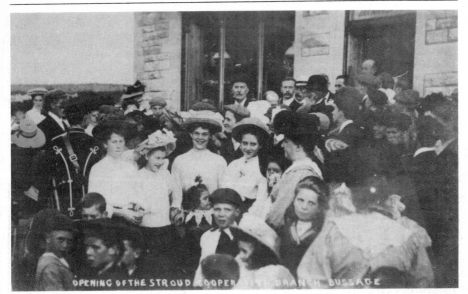

THE OPENING OF THE STROUD CO-OP SOCIETY BRANCH AT BUSSAGE, which was to serve the villages of Brownshill, Bussage and Eastcombe, early this century. Chalford Brass Band provided the music for the occasion.

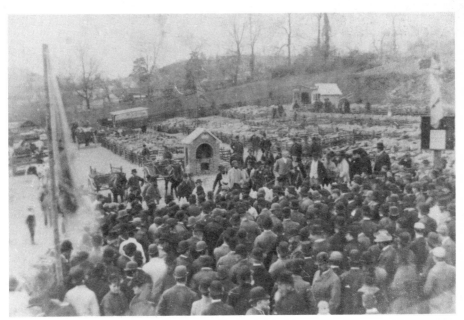

The opening of the Nailsworth Market by A.J. Playne, J.P. in April 1892, thereby giving the name 'Market' to the area today.

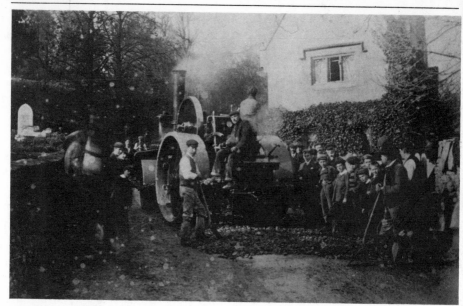

AN AVELING & PORTER STEAM-ROLLER scarifying and re-rolling the old stone road by Chalford Church, c. 1910. An occasion guaranteed to bring out boys – young and old. The bearded man in the Bargee's cap on the right of the roller is Jesse Smart and on his right is Oliver Goodship.

PHOTOGRAPH CREDITS

Mrs. Adams ● R. Baker ● E. Bassett ● D. Bird ● Mrs. Bishop
Mrs. Blacktin ● F. Blick ● W. Bourne ● Mrs. Carter ● R. Clarke ● P. Clissold
Mrs. Cove ● Dr. H. Crouch ● Mrs. Dangerfield ● B. Davis ● J. Davis
W. Davis ● B. Ede ● Mrs. Edmonds ● M. Fenton ● Rev. J. Forryan
Mrs. Francis ● Mrs. Franklin ● F. Gardiner ● J. Garner ● H. Gifford
M. Goodenough ● W. Green ● Mrs. Greening ● P. Griffiths ● Mrs. Guy
F. Hammond ● E. Harper ● J. Histed ● Mrs. Jones ● A. Lasbury
Mrs. Lewis ● Mr. Liddicott ● D. Lusty ● P. Martin ● F. Merrett
W. Merrett ● M. Mills ● A. Mutton ● A. Orton ● E. Parsons
D. Pearce ● Miss Pegg ● E. Petersen ● A. Pope ● D. Pritchard
Miss Rowles ● Mrs. Ruck ● G. Sanders ● Mrs. Smart ● C. Stagg
J. Stephens ● Miss Tuck ● C. Wells ● T. Wilkins ● Mrs. Young